Designed by Ellie Cashman, Catskill Press
Color Correction by Steve Moss, Ruder Finn Printing Services

Printed by Ruder Finn Printing Services

First published in the United States in 2003 by
Catskill Press an affiliate of
Ruder Finn Press, Inc.
301 East Fifty-Seventh Street
New York, NY 10022

ISBN #: 0-9720119-5-1

Printed in the United States of America

The Perils and Pleasures of Domesticating Goat Cheese

Portrait of a Hudson Valley Dairy Goat Farm

Pictures by Julie Cahn
Words by Miles Cahn

Catskill Press

*With grateful acknowledgement to
one thousand good goats
and fifty wonderful people
(only some of whom are portrayed here)
and especially to my wife, Lillian,
without whose support and forebearance
it would have been just another
"terrific idea."*

Contents

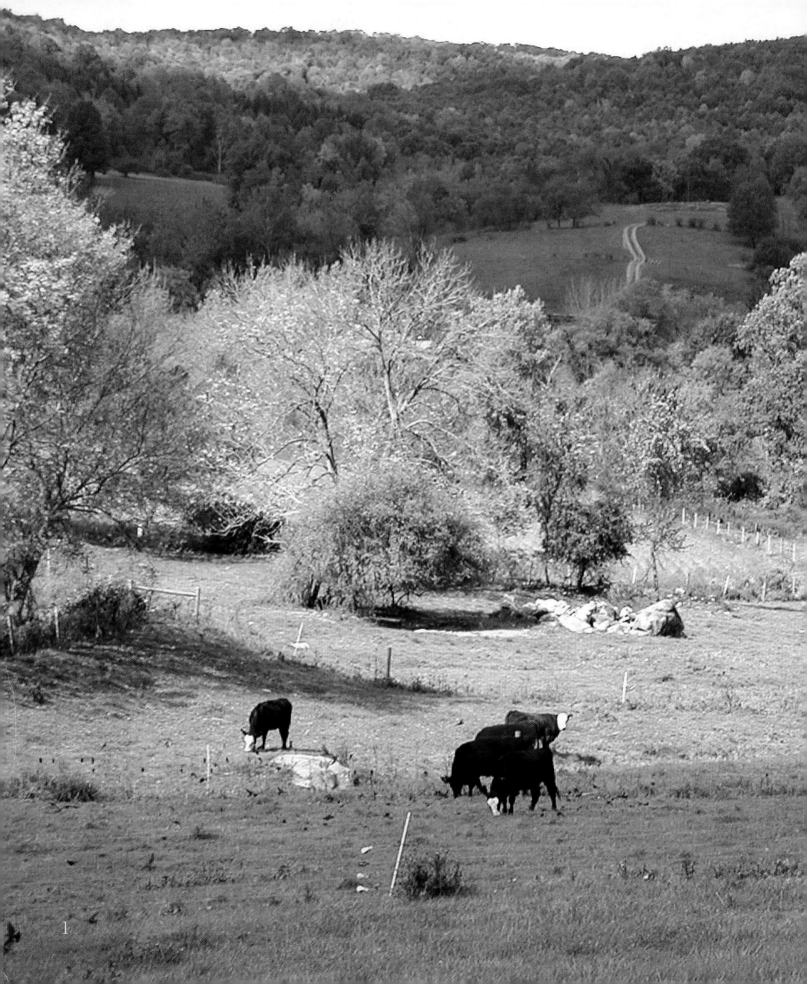

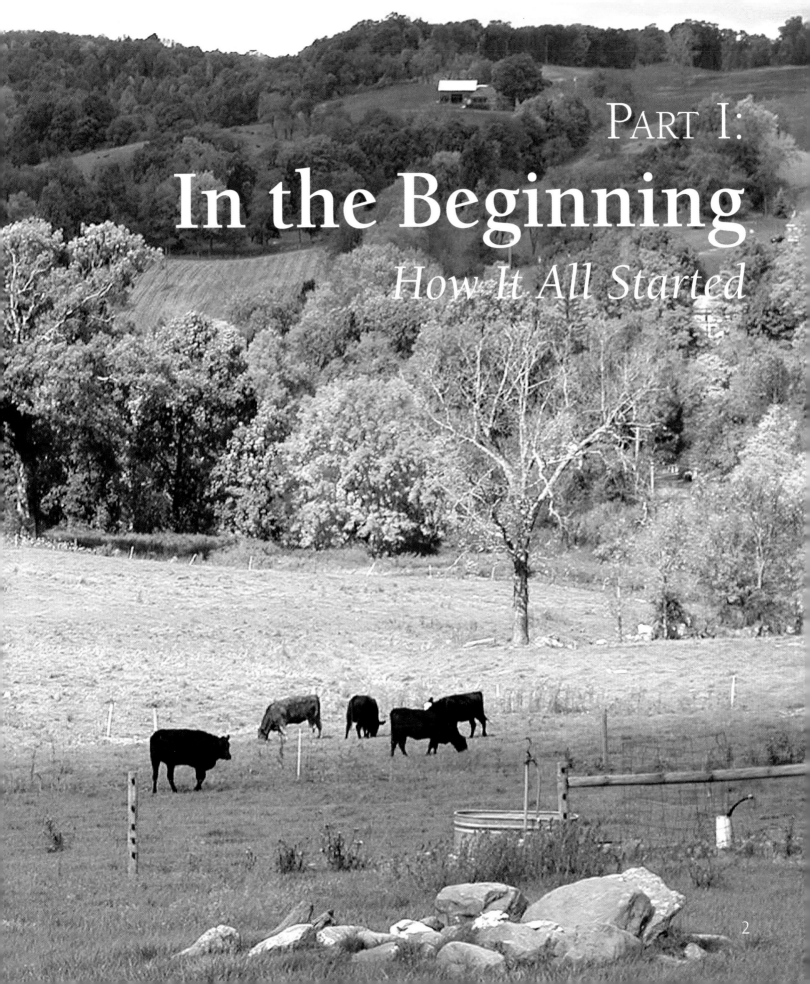

PART I:
In the Beginning
How It All Started

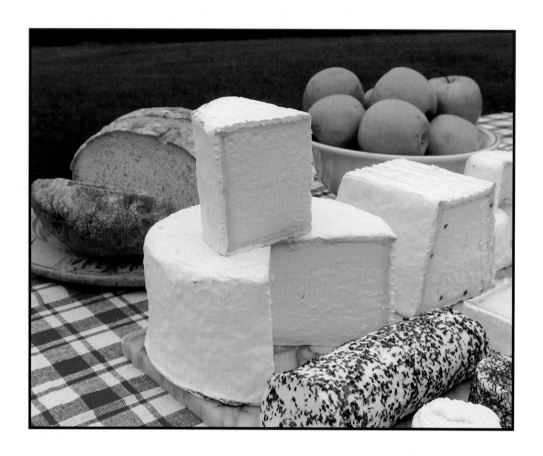

When we first began making goat cheese almost twenty years ago, many found it hard to believe that authentic, french-style, artisanal goat cheeses could possibly be produced domestically and that these cheeses were, in fact, coming from a little village only two hours from downtown New York City. I could scarcely believe it myself and, although Coach Farm goat cheeses are today a fact of life, the truth is I still find the whole thing a little unreal ...

How it all started and the absurd chain of events that made it all possible is the story we will try to tell here in words and pictures. It is actually two stories. The pictures tell one story.

They were taken by our daughter, Julie, on her frequent visits to the farm. They portray some of the many aspects of a complex but well integrated farm operation and convey images of the Coach Farm as it operates today. What it took to get it to this point – the mishaps, the miscalculations and the frustrations encountered along the way – does not show up in these pictures. That is, of course, another story. For that one we will require words, and if these words sound a little strained at times, it is because, after almost twenty years, I am still somewhat in recovery from the experience.

The story actually begins back in the previous century (the Fall of 1983 to be exact). That was when my wife Lillian and I, having just purchased an abandoned farm in the Hudson Valley, came up with what seemed like a "terrific idea" – to bring in a couple of goats and start making goat cheese.

The two of us were almost a hundred and forty years old at the time, and you would think we would have known better.

We were living and working in New York City in those days and enjoying the good life there. We had a nice apartment on the Upper West Side, and we ran a leathergoods factory downtown that, after a bumpy start lasting some twenty-five years, had finally begun turning a real profit. It was the phenomenal success of the Coach Bag that did it. A simple unlined handbag, made of baseball glove leather, the Coach Bag had somehow managed to establish itself as a classic fashion accessory. There was a Coach store on Madison Avenue and others in Boston, Washington, DC, and Seattle. There was even one in Paris. We had suddenly gone

from "bags-to-riches," and were just beginning to enjoy some of the perks that go with running a successful business. We started taking extended vacations, and there were frequent trips to Paris and London. It was a good life, all right.

But that was before we had this "terrific idea."

Today we are virtual prisoners on our own farm where, ridiculous as it sounds, we are being held hostage by more than one thousand goats! These goats are very demanding, and we are required to milk them twice a day, seven days a week – legal and religious holidays included. Each milking takes over four hours, the first one beginning at 3:30 am. (I have not yet decided whether this is very early in the morning or very late the night before). The second milking winds up around 7 o'clock in the evening, and in between milkings we are expected to provide these animals with hay, clean out their barns, care for their young and find time somehow to make a little cheese.

Now how, you may ask, did two reasonably intelligent Jewish people our age get mixed up in a business like that?

We are asked this question routinely and, given the time, I usually respond by telling the story of the young journalist who is interviewing a prostitute for his paper and is surprised to learn that she is a very educated woman and that she holds several advanced degrees in philosophy and political science. "With a background like that," he asks, "how did you ever end up in this line of work?" To which she replies, "Sheer luck."

Where a shorter, more forthcoming answer is called for, I keep a few one-liners in reserve, like:

- We must have taken leave of our senses;
- We didn't know it was impossible, or we wouldn't have done it; or simply
- Because it seemed like a terrific idea at the time.

The last one actually comes closest to the truth. But if I had to choose the one word that best explains it all, that word would have to be N A I V E T É, spelled out in big capital letters

It all began with the idea that it would be nice to have a place in the country – a farm actually – where we could enjoy a change of pace on the weekends. Now you have to understand that neither Lillian nor I had ever lived or worked on a farm, but both of us, except Lillian, had always wanted to.

In my fantasy, the farm we were looking for was going to be a real working farm, and my notion of a real working farm was the one I had gotten from a book I used to read to the children when they were very little. You've seen the book. On the cover is a picture of a farmer (Farmer Brown). He is wearing a floppy straw hat and is sitting on a tractor. He is smiling and has one hand raised in a wave. Inside, there is a picture of a red barn with a silo, and standing in front of it are a cow, a pig and a chicken and they are talking to each other. This was the sort of farm I had in mind. A real working farm. We soon learned, however, that if it was a real working farm, it wasn't for sale. And if it was for sale, it was surely not working. Like the farm we finally settled on which turned out to be a three-

hundred-acre abandoned dairy farm in Columbia County just out-side the little village of Gallatinville, New York.

Originally settled by the Dutch in 1748, Gallatinville has somehow managed to escape development and, though only two hours from Manhattan, it is today very much as it was then: a small cluster of modest houses surrounded by rolling hills and a patchwork of small cultivated fields. The farm we bought was much bigger than anything we had in mind, but it was situated in the most beautiful rural setting we had seen in over two years of looking, and we just couldn't pass it up.

Picturing ourselves going up to this beautiful farm every weekend to unwind, we could not imagine there would soon come a time when we would actually be living and working up there, trying desperately to get away from the farm and go down to the city for a little peace and quiet.

Anyway, **there we were** with this huge abandoned farm, and no idea what to do with it. You have to appreciate that three-hundred-acres to City Folks like us suggested something the size of Rhode Island or maybe even Texas. The stewardship of so vast a tract of land for which we were now responsible weighed heavily on us, and we spent the next few months trying to figure out what we could grow on this farm that would put it back into production. The few remaining farmers in the area were all milking cows and struggling to survive. We realized right away that we were going to have to think of something else — something exotic, perhaps, that we could take down to the City and market directly to the many

restaurants there. Mushrooms perhaps? Or maybe sun-dried tomatoes? And that's when we came up with this "Terrific Idea."

It is amazing how easy it is to waive all judgement and common sense when you are in the grip of what you believe to be a "terrific idea." The idea in this instance was the notion that, although our neighbors were hardly making a living milking cows, we could somehow do better with goats. Not with their milk but with the cheese we would make from the milk. (The "value added" principle, I believe it is called).

The way we figured it, we could support the farm and pay the taxes by growing hay. We would feed the hay to the goats, milk the goats, make the milk into cheese and deliver the cheese to the City in our own little refrigerated truck. It seemed to us we had come up with a whole other way of marketing hay – by passing it through a herd of goats and selling it as cheese!

You know how nice it is when you stop in a restaurant in one of those little villages in Provence and the patron brings out a platter of fresh goat cheeses that a local farmer had brought in that very morning. Well, we were going to be the local farmer, and we were going to bring our cheese, direct from our farm, to the restaurants in New York.

We were so taken by the sheer elegance of this concept that we completely overlooked the fact that at the time (hard to believe now) there was scarcely a restaurant in the whole city serving goat cheese!

We continued to skirt around this fundamental flaw in our marketing plan even as it became evident that it would take more

than a couple of goats to provide enough milk to make enough cheese just to pay the taxes, and that if we were to provide for that many animals it would require a much more substantial facility than the simple little farmstead operation we had in mind when we first started out.

Dismayed but not deterred, we proceeded to assemble an army of contractors, sub-contractors, carpenters, plumbers, roofers, masons and electricians plus an assortment of big guys apparently brought in just to stand around smoking, and began construction on an enormous complex of barns designed to eventually accommodate at least eight-hundred dairy goats. The roofing alone for all those barns was going to cost a fortune so when we were offered a choice between fifteen-year shingles and twenty-five-year shingles with a chance to save a few dollars, we chose the fifteen-year shingles (all of which, of course, had to be replaced exactly fifteen years later at a cost many times the original savings).

And then there was the cheese-making facility itself. In consultation with just about anybody who struck us as knowing even a little more than we did, we built a small, white-tiled creamery adjacent to the milking parlor complete with holding tanks, a small pasteurizer, a row of stainless steel tables and several walk-in coolers.

Considering our profound ignorance, we managed somehow to get a lot of it right. There was a small problem, however. One of the basic requirements of an operating cheese-making plant, we learned, is a good supply of water. Unfortunately, there was only one well on the farm and it clearly wasn't going to be enough. So a team of well diggers had to be brought in to correct the problem. After numerous attempts, they finally managed to hit a good flow of water, guided there by a drunken dowser wielding a bent coat-

hanger – but not before he had misdirected us to dig three very deep, very costly holes that yielded no water at all.

While all this was going on, we also acquired a black and white cow we named Rosie, a pink pig named Phyllis, a bunch of chickens, and two Rhode Island Red roosters named Bernie and Murray. I had realized my fantasy at last. It was a real working farm.

But our costs were running even higher than our highest estimates and, with all the money we had spent, we still hadn't sold a pound of cheese. With the arrival of the first goats (two-hundred of them trucked in all the way from Wisconsin), it was Lillian who noted pointedly that, while our idea no longer seemed so terrific, there could be no turning back now.

Setting up a commercial farmstead goat cheese operation on a scale large enough to pay its own way had turned out to be a huge undertaking, way beyond anything we had contemplated when we first started out. We were beginning to realize that this venture required a full-time effort and that we could no longer continue to run it as a weekend project. Rushing back and forth between Coach Farm and the Coach Factory, we had lost all sense of which was "back" and which was "forth." Clearly, we would have to give up one or the other, but first we were going to have to determine which of the two was the "other."

To abandon the farm at this stage would be to admit defeat and accept the fact that we had lost a lot of money. Worse than that, it

would make us look very foolish to our friends and family. On the other hand, how could we possibly part with our leathergoods business after all those years, especially now that it was beginning to make money?

We agonized over these two choices as we shuttled back and forth between the farm and the factory, and ultimately it was the "fear of looking foolish" that prevailed. And so in July of 1985, we sold the Coach Leatherware Co. to the Sara Lee Corporation and moved up to the Coach Dairy Goat Farm to begin a new life there, settling into a house we had built up on a hill overlooking the barns.

Once we were living on the farm full time, we were able to concentrate full time on trying not to appear foolish, but with little success. To the local farmers, accustomed to milking Holstein cows that can give you up to one hundred pounds of milk a day, the idea of milking goats that average no more than seven pounds a day was just plain ridiculous. They didn't think we were foolish. They thought we were crazy.

Even our three children – no longer children – were beginning to question Mom and Dad's stability – especially Dad's. From their perspective, Dad was going through some sort of post-menopausal episode, while Mom was trying to keep him from going over the edge at the risk of going over the edge with him.

But it was our otherwise reasonable accountant that I really wanted to impress. I kept going over my "business plan" with him, trying to convince him that my projections were correct and that we

would soon be enjoying substantial profits. But he remained unimpressed. I flirted briefly with the notion of switching to another, perhaps more impressionable accountant, but on reflection thought better of it and set out, instead, to prove him wrong.

Over the next several years, however, the substantial earnings I had anticipated never materialized, and we were confronted instead with substantial losses. Our situation was growing desperate, so desperate, in fact, that at one-point we would have welcomed an unfriendly take-over. There were a lot of hostile bids going around at the time, but no one thought of approaching us, and so, we had no choice but to keep right on going.

It took us almost five years of these substantial losses before we were able to finally experience what, under the circumstances, can only be described as "The Joy of Breaking Even." And it was not until several years after that, that we were finally able to share a little of our meager gains with the Internal Revenue Service. It had taken way too long and cost much too much, but I still prefer to believe that I had been right all along and that it was our accountant who had been wrong.

So how did we manage to do this? Frankly, I do not know. I am still amazed that the whole thing ever came together at all, but I do know that it was largely the fear of failure and ridicule that kept us going and that we learned a lot of things along the way.

The first thing we had to learn was how to make good hay. It was essential to our "business plan." Our goats required good hay in order to produce good milk, which we could then process

into good cheese that would fetch a good price – a price, that is, in excess of what we would have gotten for the hay had we sold it in the first place instead of feeding it to the goats.

There is a popular saying that "you have to make hay while the sun shines." While city folks may find this saying subject to different applications, it must be taken quite literally if you intend to make good hay. A good yield of hay requires rainfall while the hay is growing, but after it is cut it has to lie in the sun for around three days before it is dry enough to be baled. If it should rain while the hay is still on the ground, the leaves will fall off and the hay will be reduced to stems and stalks good only for bedding. The trick, therefore, is not to cut the hay if you think it might rain over the next three days. But if you waited until you were absolutely certain, the hay would never get cut. As you can see, the success of our entire project is completely dependent on when and how much it rains. This is why we stay tuned to all the weather reports, some of which turn out to be right, but only some of the time.

As if coping with the weather weren't enough, we also have to put up with a growing population of deer who come out of the woods in great numbers to graze on our fields. A single white tail deer is a beautiful creature to behold, but watching a whole herd of these beautiful creatures (as many as fifteen to twenty of them at any one time) consuming the hay that was intended for our goats is not quite the same thing. These deer were born and raised on this farm. They live here. So waving and shouting at them to go home makes no sense at all. What we do, therefore, is try to grow enough hay to support their needs as well as our own. This has to add something

to the cost of our already expensive cheese, but exactly how much I would prefer not to know.

Our farm manager doesn't look anything at all like the Farmer Brown I had envisioned. He doesn't wear a floppy straw hat and he's not much for sitting on his tractor and waving. Actually, he is a graduate of the University of Massachusetts where he must have majored in Growing Good Hay in Poor Soil. With regular applications of fresh goat manure, he has over the years improved our soil greatly. The barns are cleaned out regularly and all those wonderful rich nutrients are recycled back into the earth. Hauling manure out of the barns and spreading it onto the fields, it seems, is a good part of what keeps a working farm working. Clearly, there is much more to a steaming load of fresh goat manure than the crude four-letter expletive would suggest.

It takes a number of tractors and a variety of intricate laborsaving equipment to plant and bale hay efficiently. The labor saved, however, is offset by the considerable labor required to keep all that farm machinery in good repair. This gives us something useful to do after all the hay has been cut, baled and stacked in the barn and before it is time to start planting all over again. So much for free time.

With the help of an experienced herdsman, brought in from Tennessee, we also got to learn an awful lot about goats. For one thing, it is not true - they do not eat tin cans. Coach Farm goats do not have to forage in the garbage looking for something to eat. Far from it. Our goats live in great luxury with a

retinue of servants to bring them everything they need, and they can therefore afford to be very finicky eaters.

This can create something of a problem for us. If our hay is not quite up to their high standards, they simply walk away, knowing full well that if they just leave it there, we, their faithful servants, will take it away and bring them something better. That was the other thing we learned about goats. They are very smart.

While they don't eat tin cans, our goats do lots of other very interesting things – some of which you may have always wanted to know more about but were afraid to ask. Here are just a few of the basic facts of life that we picked up in the course of going about our business.

As you may know, the female goat is called a "doe" (not a lamb) and the male is called a "buck" (not a ram). Fact: You should not expect to get milk from a buck. Don't laugh. We have been asked that one on several occasions by otherwise very accomplished grown-ups visiting us from the city.

It is also a fact that almost everything these goats are involved in is somehow related to, or the direct consequence of, having had unprotected sex. But notwithstanding this lifestyle and the bad rap that goats get generally, I must tell you that our does are clean, sweet, intelligent creatures – each one a delightful pet with a distinct personality and her own name.

The bucks are something else again. The strong "goaty" smell that is incorrectly associated with all goats is actually produced by a special gland in the buck, and it announces his readiness, his

determination really, to pass on his genes to the next generation. Nature has programmed him to do this, and when the mating season comes around, he can think of nothing else. To make himself even more attractive, he will direct a stream of urine onto his beard – his equivalent, no doubt, of splashing on a little cologne just before going out on a date.

And it works.

The doe readily succumbs to this fragrance, and the deed itself, with little foreplay to speak of, is over and done with in a matter of seconds. Five months later she gives birth and her udder fills with milk. This milk is of course intended for her kids, but under the special arrangement we have with her, she gives us her milk in return for our hay, and the kids are raised on formula. The milk is collected twice a day and pumped into the creamery where it is pasteurized and made into cheese. Sounds simple? Well, it isn't.

For one thing, the readiness of the doe to accept the attentions of her determined suitor is, unfortunately, confined to only a short period once a year in the Fall. This puts something of a strain on the buck, but it places a burden on us as well, for the does, having all been bred in the Fall, will start going into labor all at the same time in the Spring, giving a whole new meaning to the term "labor intensive."

Despite our efforts to stretch out this natural breeding season, there are literally hundreds of kids born each Spring, and they keep us

very busy preparing formula and tending to their special needs. These kids are very precocious. After only a few weeks in the nursery, having only just been weaned, they are already demonstrating signs of sexual activity and are ready for Junior High School. We have managed to keep teenage pregnancies down to a minimum, but only by providing separate classroom and playground facilities for the young bucks.

In order to keep improving the genetics of our herd, and to bring in additional bloodlines, as well, we also do a certain amount of artificial insemination. For this purpose, we purchase straws of frozen semen which we store in a special nitrogen tank that is kept on the premises. Depending on the quality of the buck and, most importantly, the milk production records of his daughters, a single serving of this ejaculate can cost as much as $50. In a herd our size this could add up to big money. The fact is, however, that many of our does still do it for a buck.

If you have reason to believe a doe may indeed have "done it for a buck," it is important to verify pregnancy as soon as possible as she will not be receptive again until the following year. We accomplish this with the help of a sophisticated ultra-sound device that determines whether she will be moved into the maternity ward or sent back to the barn with the admonition to stop passing the buck.

As you can see, it is easy to make jokes about our animals and their open sex lives, but caring for a large herd of dairy goats is really no laughing matter, and we take it very seriously. Goats are prone to as many maladies and health problems as we are, but I venture to say

that our goats are better housed, better treated and more carefully watched over than a good part of the human race.

But now let me tell you a little bit about how we make our cheeses – also a serious business.

We had set out to make the sort of artisanal goat cheeses that we first encountered in the French countryside. These cheeses are made fresh every day by the local farmers from the milk of their own carefully tended goats. There is a distinctive character, a special quality, to these French goat cheeses that we were determined to duplicate in Gallatinville. Needless to say, there was no one right here in Gallatinville who could show us how to make authentic French goat cheese. For that we had to bring in an authentic French cheesemaker.

Marie-Claude was her name and she was authentic all right. She came from a small village near Bordeaux, where she lived with her three children and sixteen goats. At night, when the children were asleep, she would go into the kitchen to make her cheeses with nothing more to work with than a few buckets, a thermometer, a hand ladle and a small collection of perforated draining molds. Her cheeses had won a number of regional competitions, and she had a nice collection of blue ribbons to show for it.

Marie Claude moved onto the farm with us, and over the next two years, our Gallatinville locals apprenticed under her and mastered her techniques. These local apprentices are today authentic cheese-makers in their own right, turning out the sort of traditional goat cheeses you would not expect to find being made in this country.

The remarkable thing is that, after all these years, despite greatly increased production, we are still making our cheeses exactly the way Marie-Claude did it in her kitchen, hand-ladling the fresh curd into individual draining molds. The only difference is that our milk is first pasteurized, as is required by law.

I had read about Louis Pasteur and remembered seeing the movie with Paul Muni, but I still had no understanding of the microorganisms that turn milk into cheese. I assumed that all we were required to do was heat the milk, cool it down and add the right cultures – the same ones used in France – and that these little bugs would then do the rest. Well, it turned out that there is very little these little guys can do without considerable support from a trained cheesemaker.

Temperatures are critical. So is timing and a great attention to detail. And most of all, it's the sanitation. For every good bug that can help you make your cheese there are dozens of predatory bugs lurking out there, ready to pounce on the good bugs, take over the creamery and spoil the cheese. The cheesemaking process must be focused on keeping the bad bugs at bay and encouraging the good bugs to be fruitful and multiply. This entails constant washing and sanitizing, and the fact is we spend as much time scrubbing the place down as we do making the cheese.

After the milk has been pasteurized and the cultures added, it is pumped into thirty-gallon tubs and wheeled into a separate incubating room where it stays overnight at slightly elevated

temperatures. The following morning, lo and behold, the milk has curdled. If this happened to you at home, you would probably throw it out. But we don't.

Some very hungry person a long time ago must have discovered that if you removed the curd from the curdled milk, you could spread it on a piece of bread, call it cheese and have it for lunch – just like little Miss Muffet who, you will recall, before being frightened away by the spider who sat down beside her, was sitting there eating her curds and whey. We are certainly familiar with both curds and whey, as separating the one from the other is central to the whole cheesemaking process.

The curd is lifted out of the tub with a perforated ladle, slipped carefully into individual draining molds and allowed to sit there overnight – the whey seeping out of the tiny holes in the mold. A thousand pounds of milk yields only about one hundred pounds of cheese, and that leaves you with nine hundred pounds of whey that must be disposed of somehow. We are fortunate to have a neighboring farmer who comes by every day, pumps it out of our tank and hauls it away to feed his beef cows. The whey is still rich in nutrients, and the cows seem to thrive on it.

By the following morning the curd has settled into a firmer consistency and can already be plopped out of the mold. It is now a piece of very soft cheese, its shape determined by the shape of the mold. It is lightly salted, set out on a rack and taken into the cooler where temperature and humidity are carefully monitored. And that's the whole process. It has been only four days since the

milking and these cheeses are ready to go. They are wrapped in special papers that allow them to breathe (never vacuum-packed), put on our truck and taken down to the City. Fresh goat cheese doesn't come any fresher than that.

We deliver our cheese three times a week to specialty markets and restaurants throughout the City. Goat cheese has gained considerable acceptance since we first started, and today there is scarcely a restaurant that doesn't serve goat cheese, for which we must accept a good share of the blame. Our poor, much put-upon drivers, however, are increasingly frustrated by the City's impossible traffic. They put in fourteen-hour days, leaving the farm at 3 am in order to avoid the morning rush hour. Once in Manhattan, they cope as best they can. Sometimes, after having circled the block a few times in search of a parking place, they will, at the risk of a fine, pull into a "No Parking" zone in order to complete their deliveries and start back to the farm before the evening rush hour begins. Sometimes they get away with it; sometimes they don't.

And there you have the whole story in all its absurdity – a series of wildly improbable events, driven by the desperate efforts of a naïve leathergoods manufacturer not wanting to appear foolish, and concluding with the delivery of a $50 case of goat cheese logs and the very real prospect of a $100 parking ticket!

As I said, it seemed like a "terrific idea" at the time.

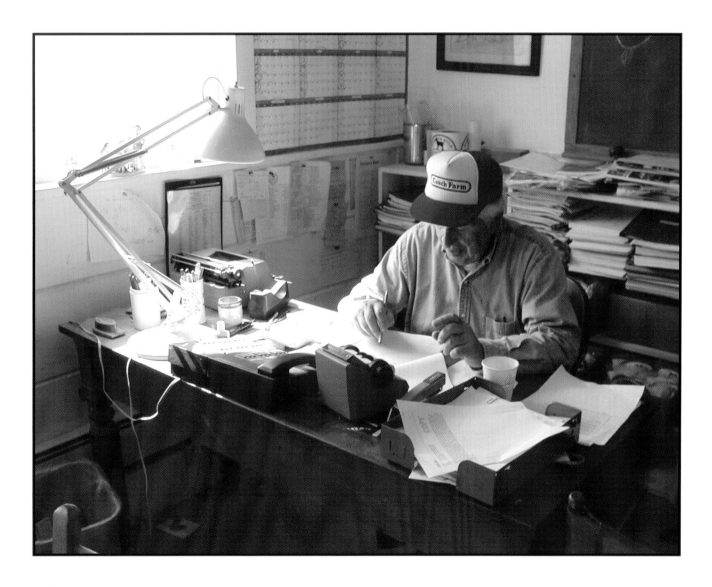

The man in this picture appears to be completely absorbed in his work, but he is actually counting the days until he will be able to get away from the Farm and go down to the City for a little peace and quiet.

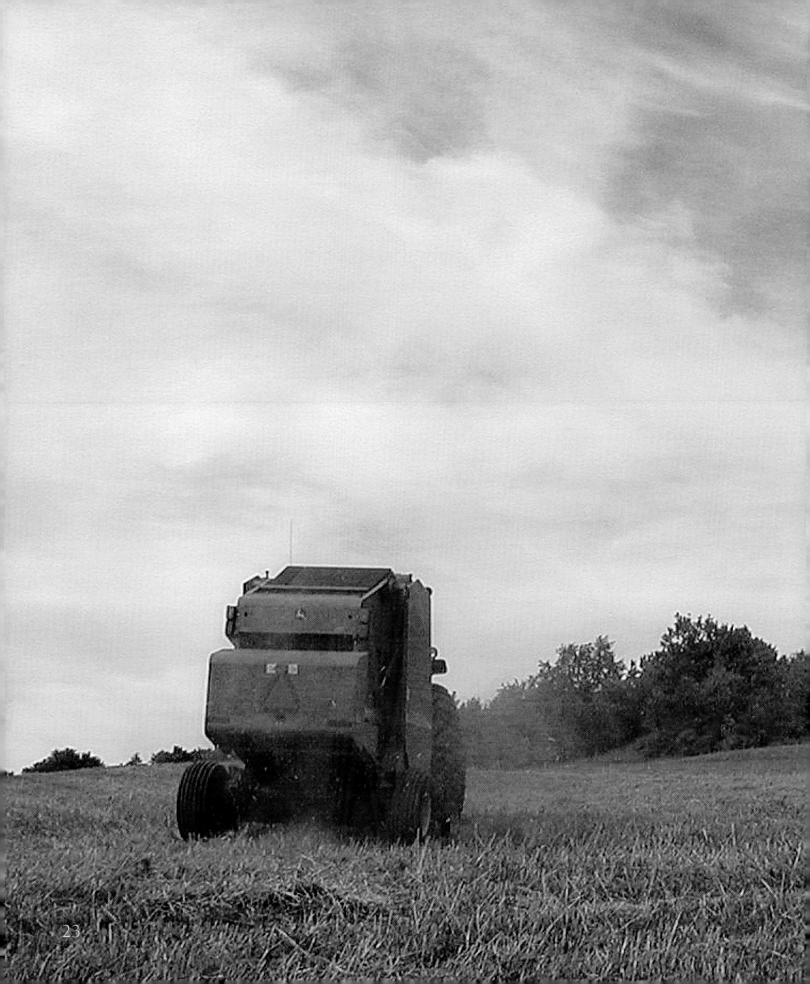

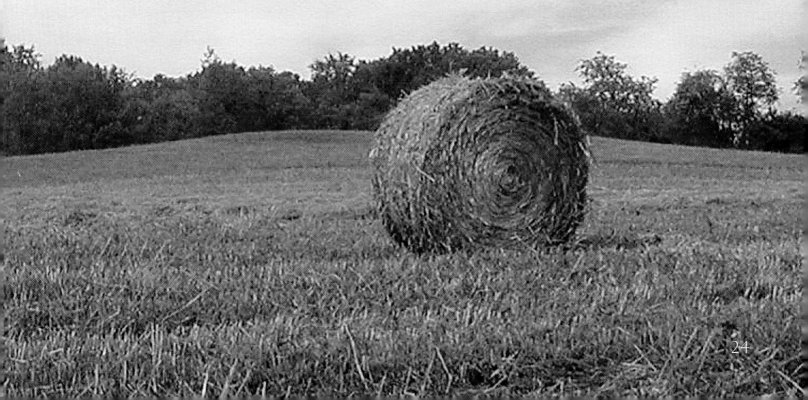

Part II:
In the Fields
Making Hay While the Sun Shines

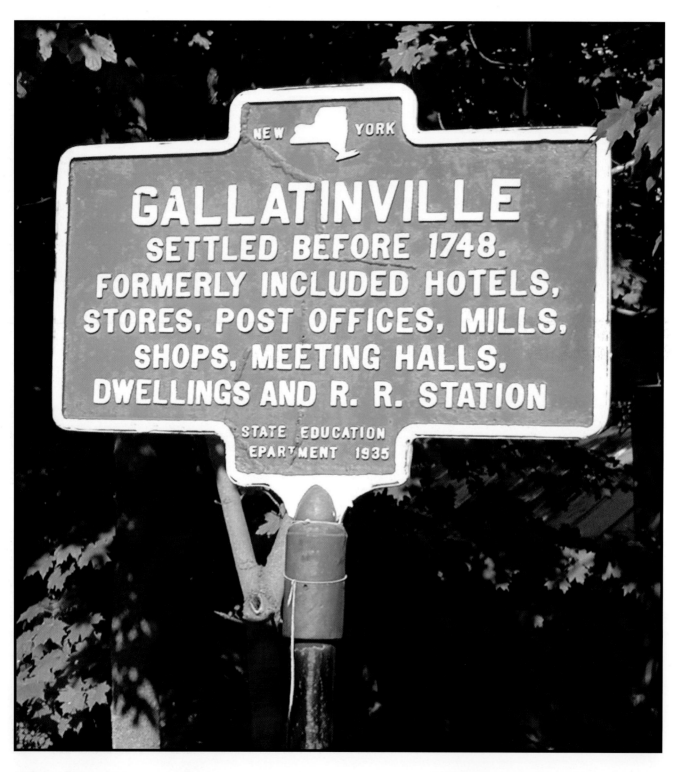

This historic marker is at the corner where you turn onto Mill Hill Road. There is nothing here now but a cluster of little houses and a dairy goat farm up the road.

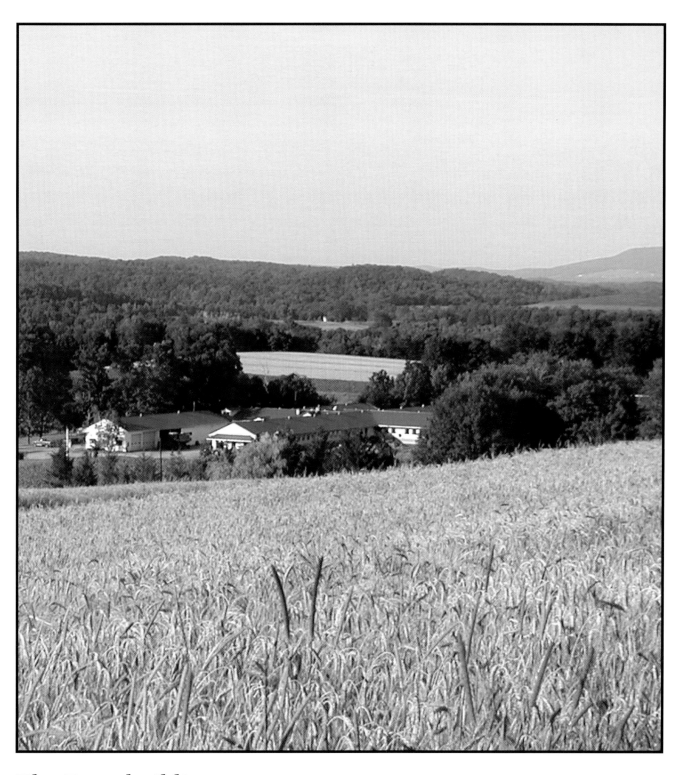

The Farm buildings are nestled in the hilly terrain of the Hudson Valley that lies between the Catskills and the Berkshires – just two hours from Manhattan.

These old barns are still standing on the Coach Farm. They were built almost a hundred years ago and are unfortunately beyond restoration . . .

. . . They will be taken down one day and their massive, hand-hewn beams reclaimed. Till then they continue to provide storage space, which is always in short supply.

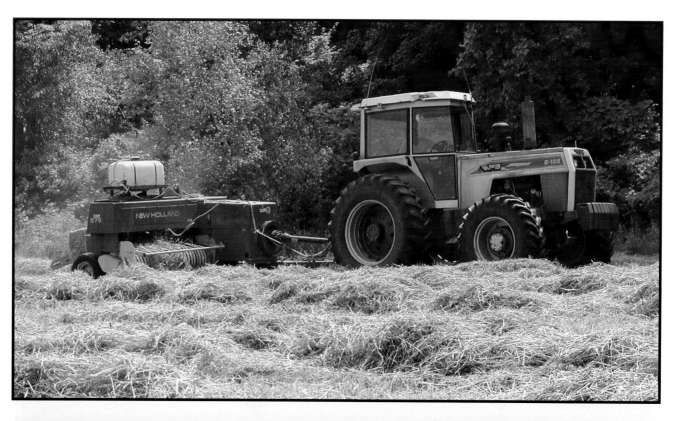

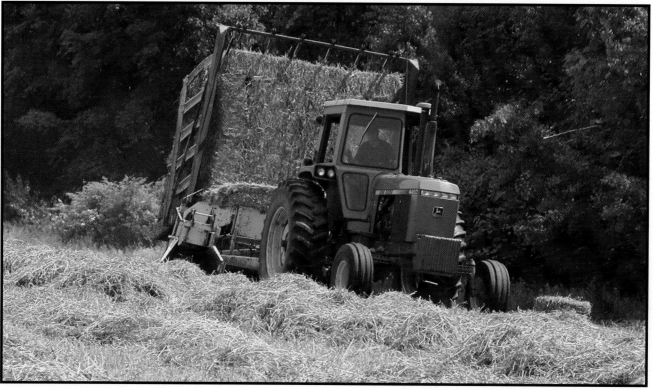

29

Between June and September there can be as many as three or four cuttings of hay. After it is cut, the hay is allowed to dry in the sun for a few days (weather permitting) before it is baled and taken away. With specialized farm machinery, a single operator can clear a thirty-acre hayfield all by himself, gathering the hay into fifty-pound square bales, loading them onto a wagon, carting them away and stacking them in the barn – all without having to ask for help.

A small herd of beef cows grazes on the hillside. We keep them for the express purpose of consuming the hay that isn't quite good enough for our finicky goats. No tin cans for them, our goats demand and get the choicest cuttings of sweet-smelling alfalfa hay.

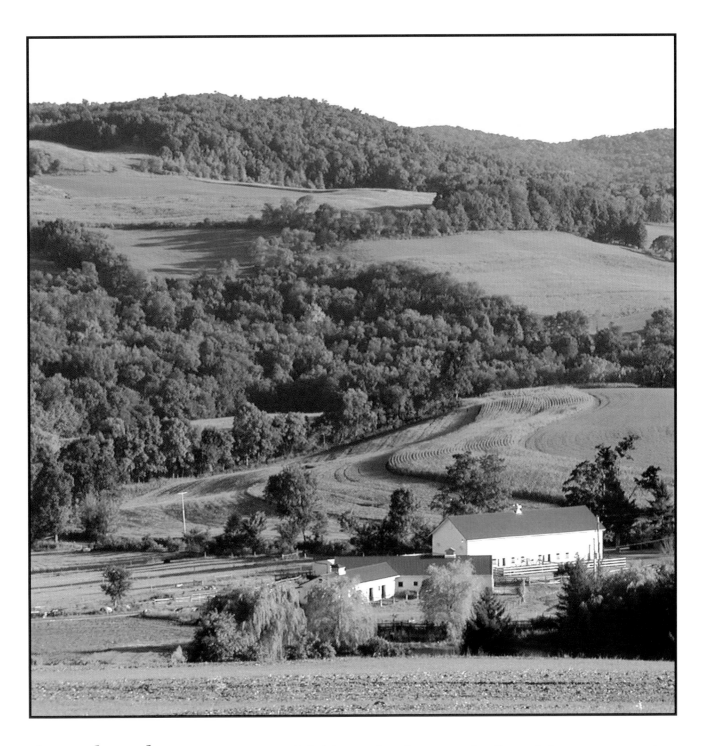

A patchwork of small cultivated fields on the slopes and a few of the contour strips that are part of an ongoing soil conservation effort. A conservation easement registered with the Columbia Land Conservancy will continue to protect this open landscape for many years to come.

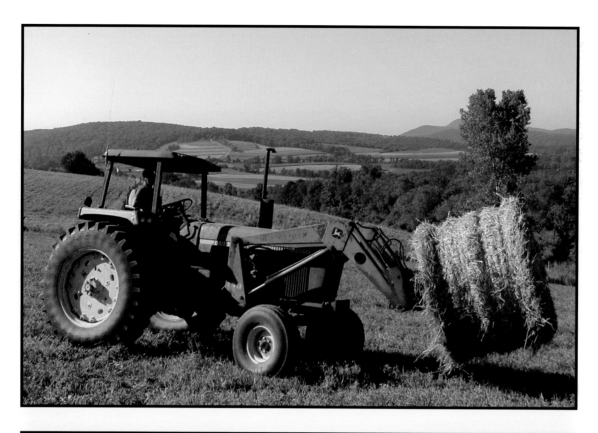

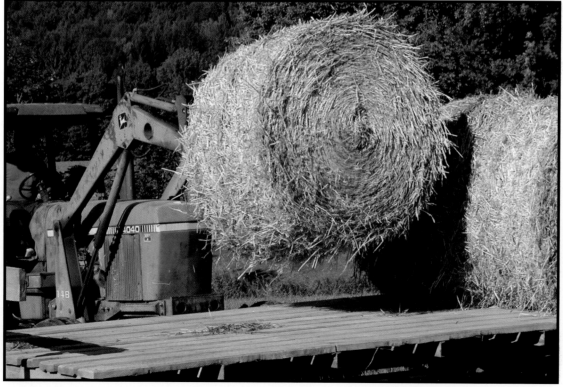

35

A dozen round bales, each one weighing as much as a ton, are picked up, loaded onto a pair of flatbed trailers and hauled away in a matter of minutes. They will then be sheathed in plastic and stored outside.

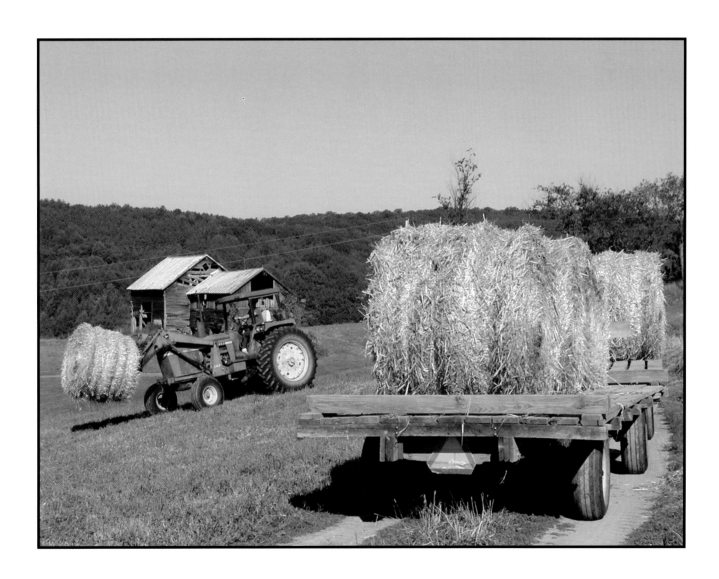

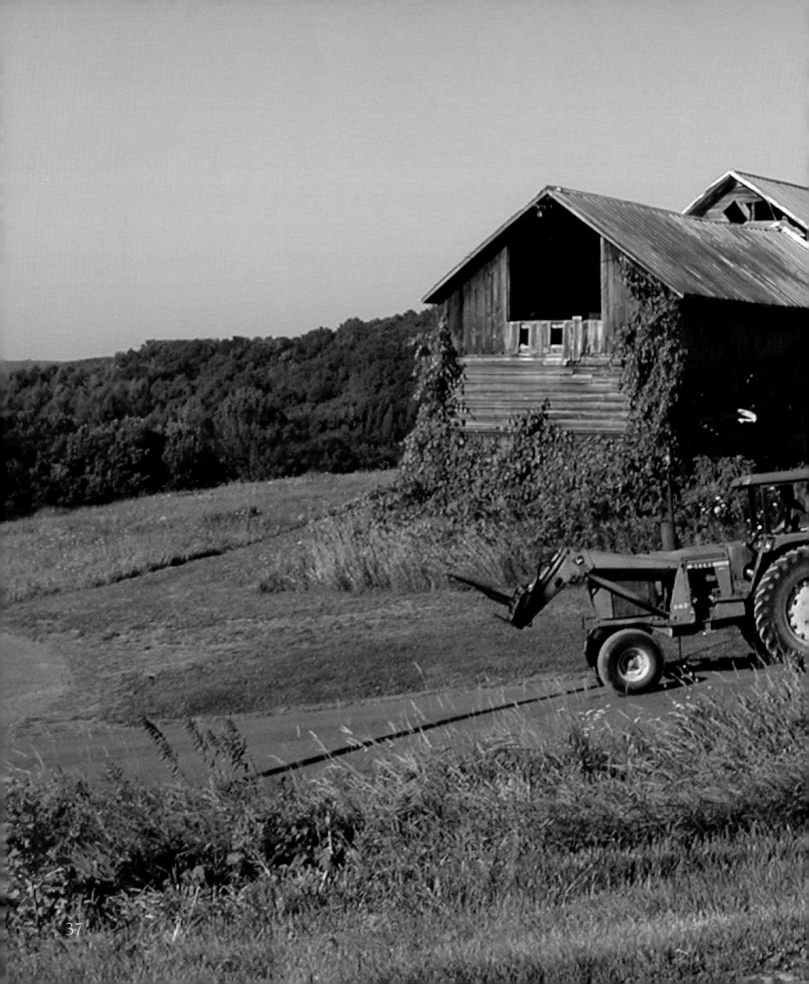

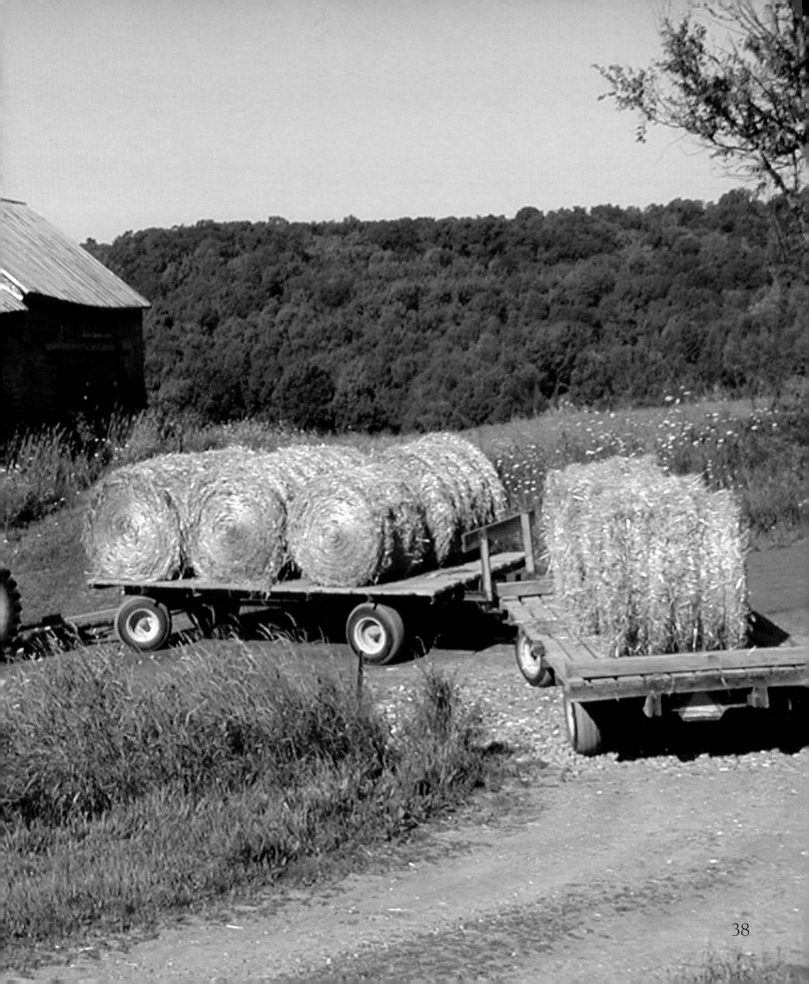

38

Hundreds of round hay bales, now sheathed in continuous plastic tubing, are stored outdoors in an area the size of a football field. With one thousand goats to feed, it takes this much hay to last through the winter months, until the next cutting.

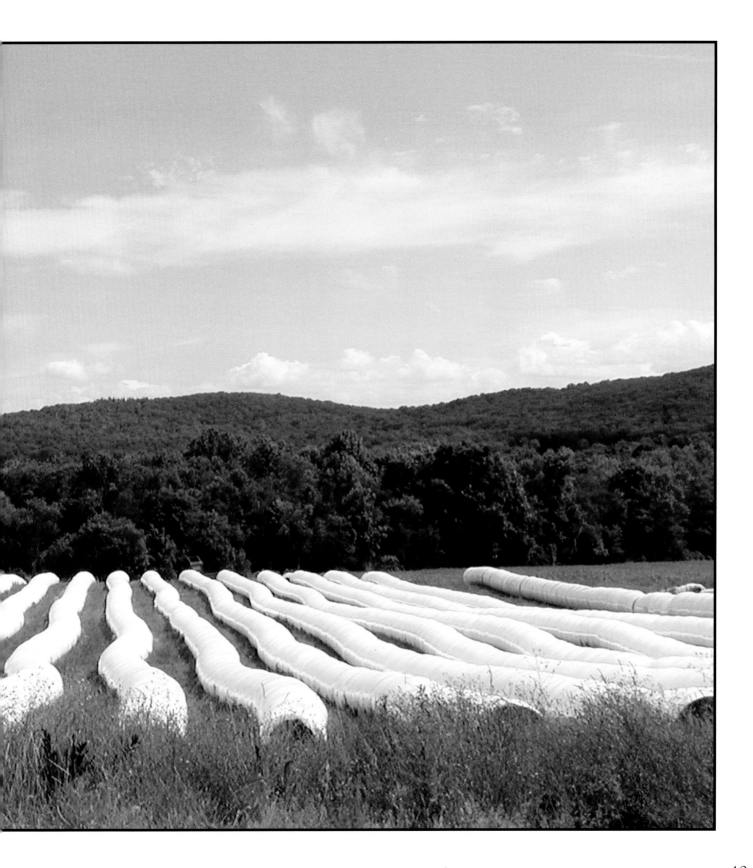

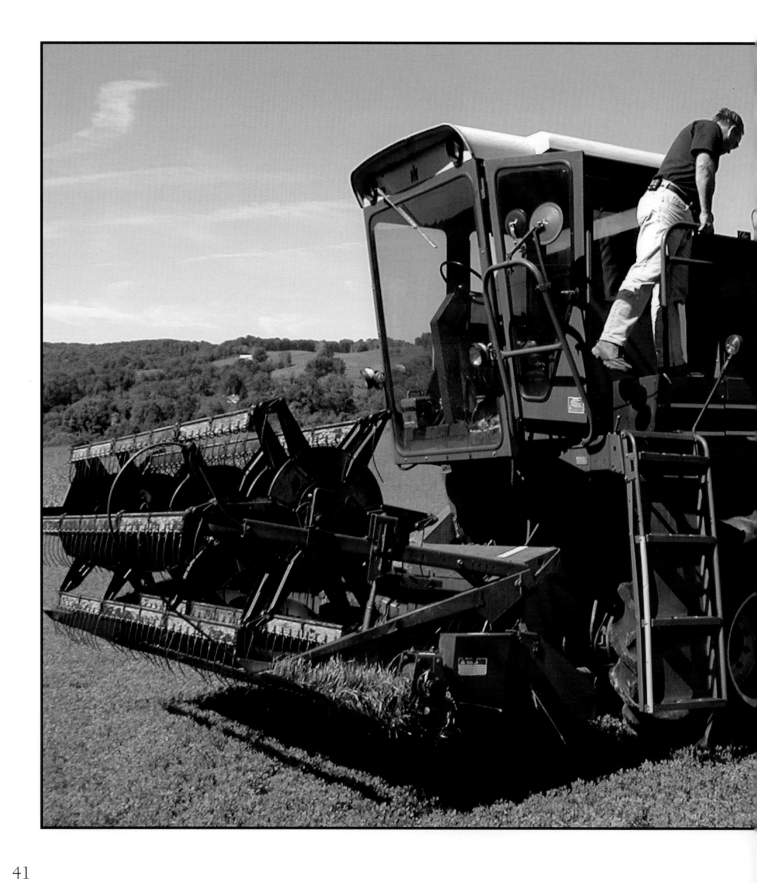

The combine is the biggest piece of machinery on the farm. It is used for harvesting corn and various other grains, cutting the plants and collecting the seeds from the stems in a single pass.

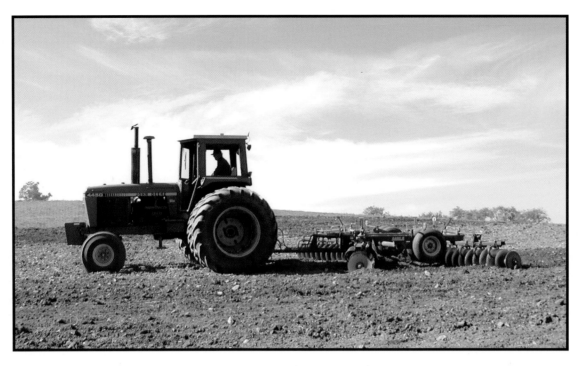

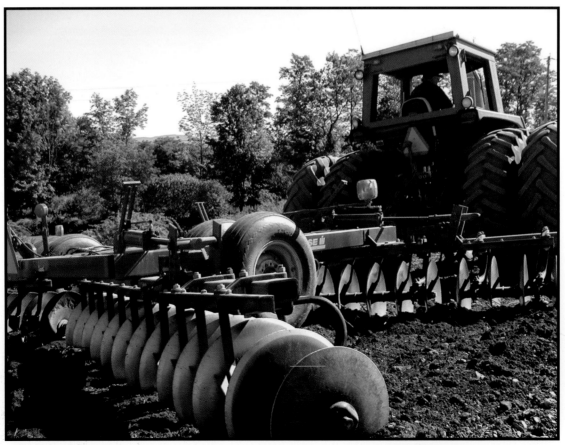

The Discer, with its sharp blades, is pulled across a ploughed field, breaking up the larger clumps of topsoil in preparation for seeding.

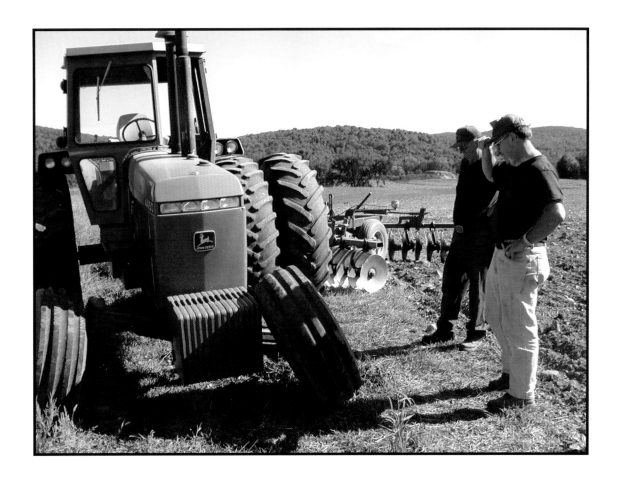

A flat tire is viewed with some dismay. But it could have been worse. Had it been one of the large tires, it would have set the farm back almost a thousand dollars to have it replaced.

Labor-saving machinery can perform a variety of complicated tasks, but a good part of the labor saved is taken up trying to maintain it in good operating condition.

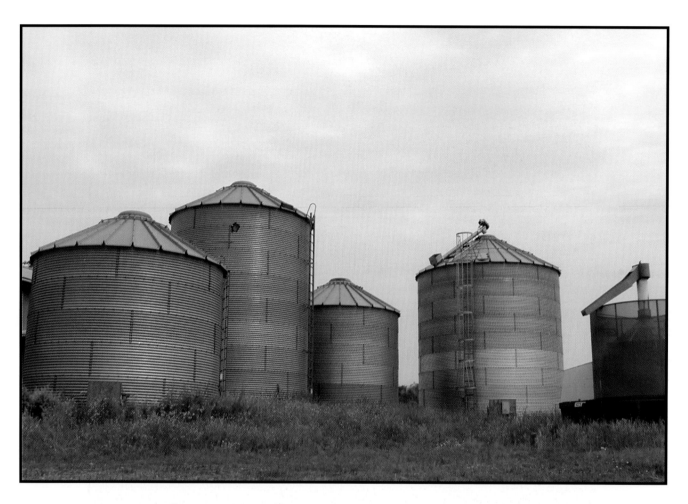

Grain storage bins. The goats are fed a mixture of grains grown on the farm. They include corn, wheat, barley and soy beans and are drawn from these bins as needed. Surplus grains are also held here and sold when the price is deemed to be right.

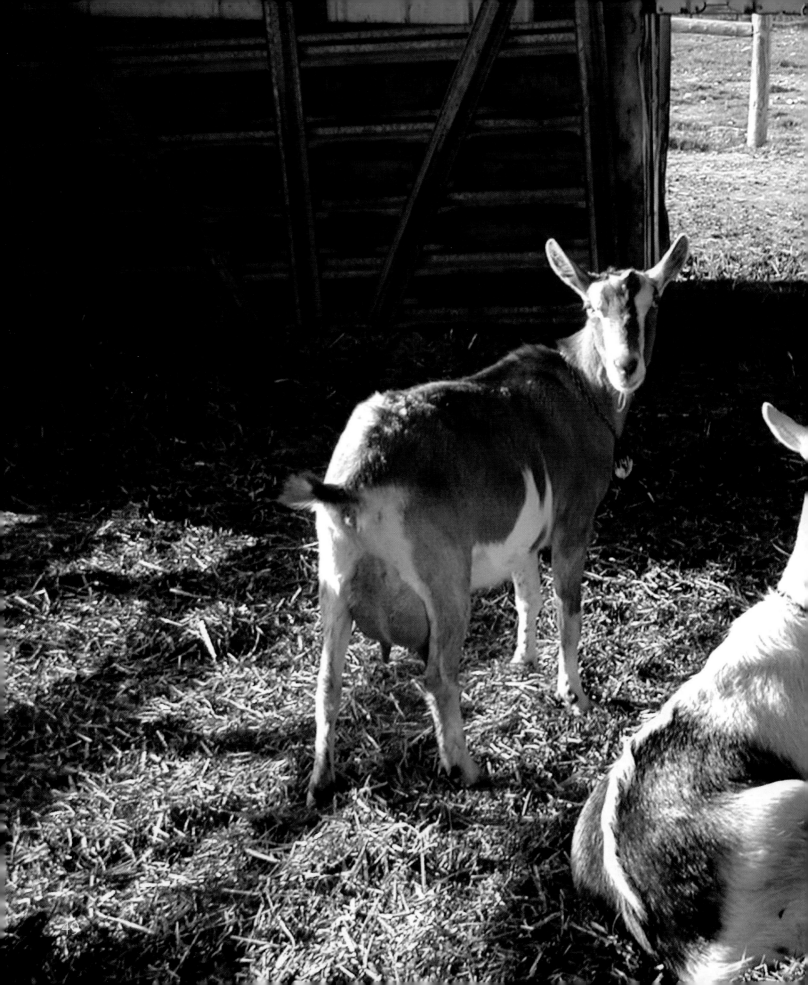

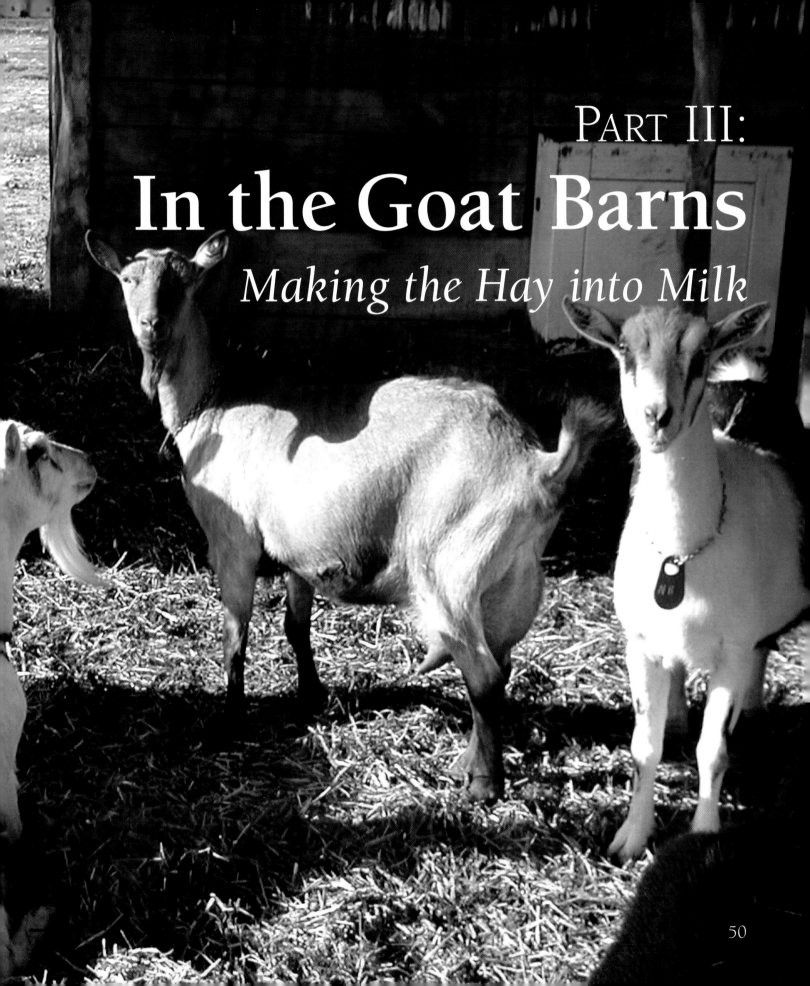

PART III:

In the Goat Barns

Making the Hay into Milk

The Chorus Line. Starting from the left, there is: Beverly, Hillary, Valerie, Monica, Linda, Liz, Agatha, Alice, Charan, Jessica, Jean, Candy, Wendy, Martha, Mary, Mildred, Phyllis, Pam . . .

51

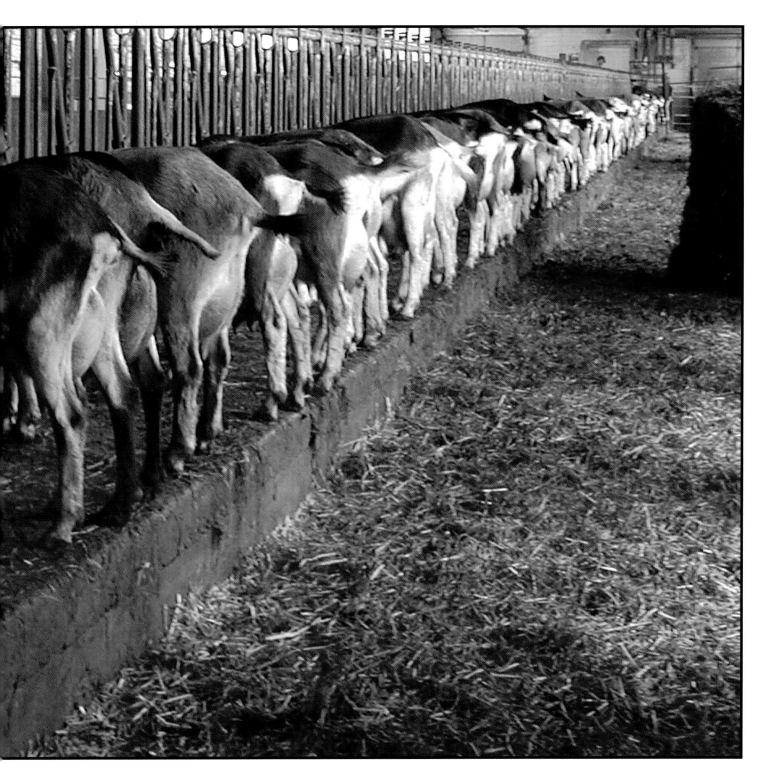

. . . Faith, Susi, Patti, Jane, Vicky, Cindy, Maggie, Ellie, Audrey, Francis, Julie, Gloria, Lisa, Laurie, Rose, Jenny, Sheri, Jeanet, Morgan, Denise, Lillian, Thelma, Louise, Rosie, Debbie, and Dot.

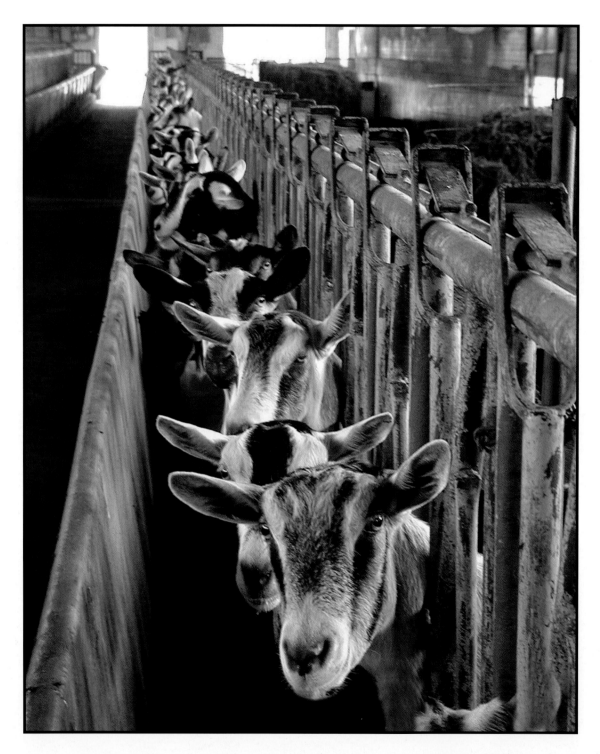

And this is how they look from the front. Actually they are lined up anticipating a feeding of grain, but this is also a good time to check for runny noses.

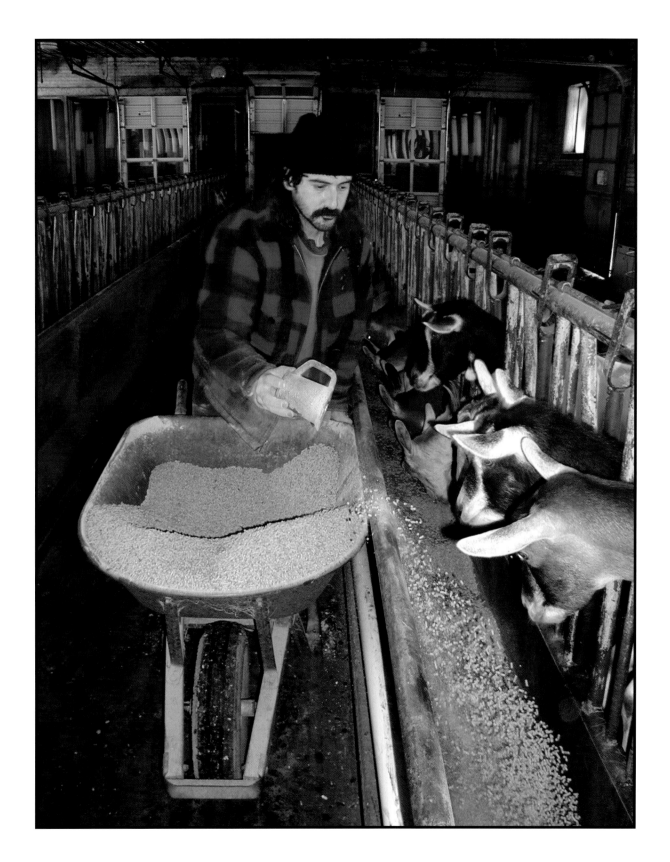

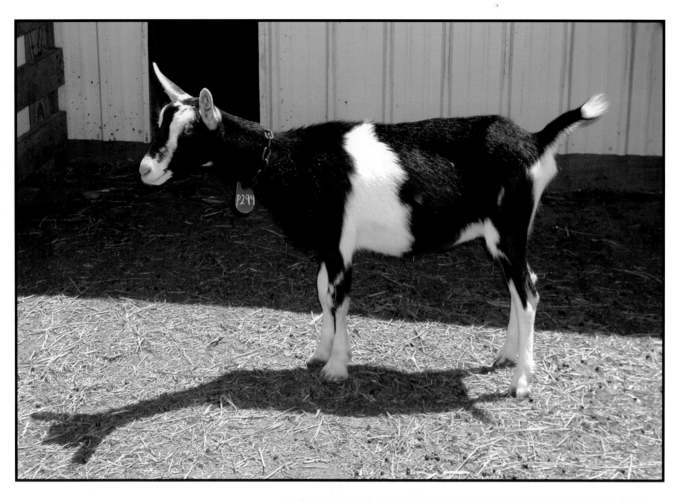

Pure-bred Alpine goats, unlike most other goat breeds, do not all look alike. This makes it easier to recognize individual animals and get to know them on a first-name basis.

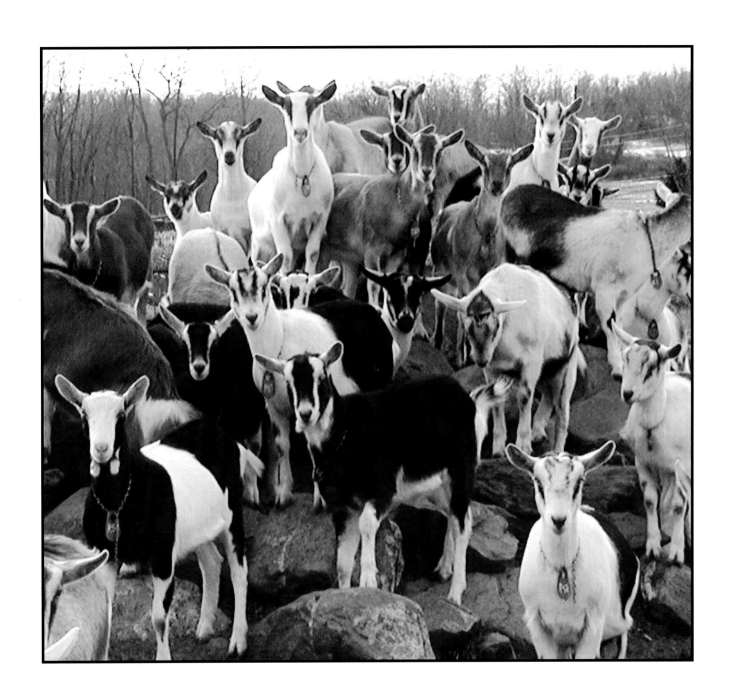

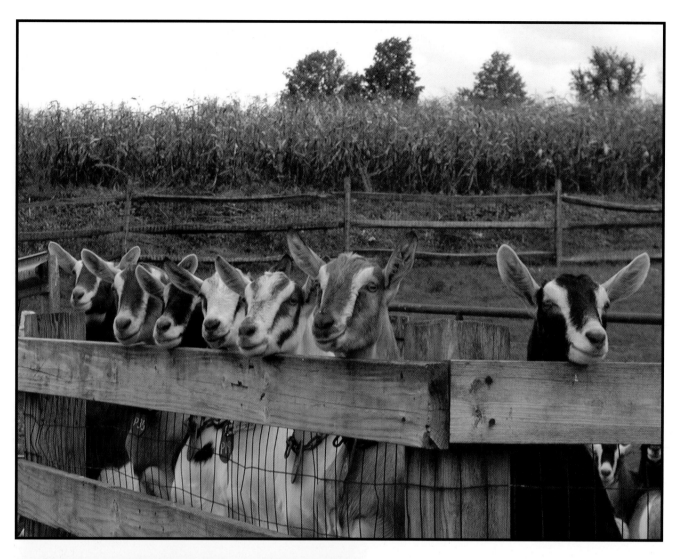

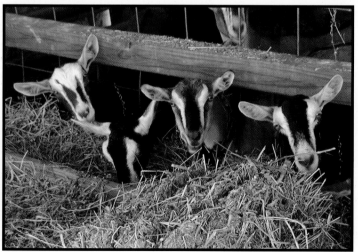

Goats are curious creatures. Point a camera at them and they will look up, stop what they are doing, and come over to see what's going on.

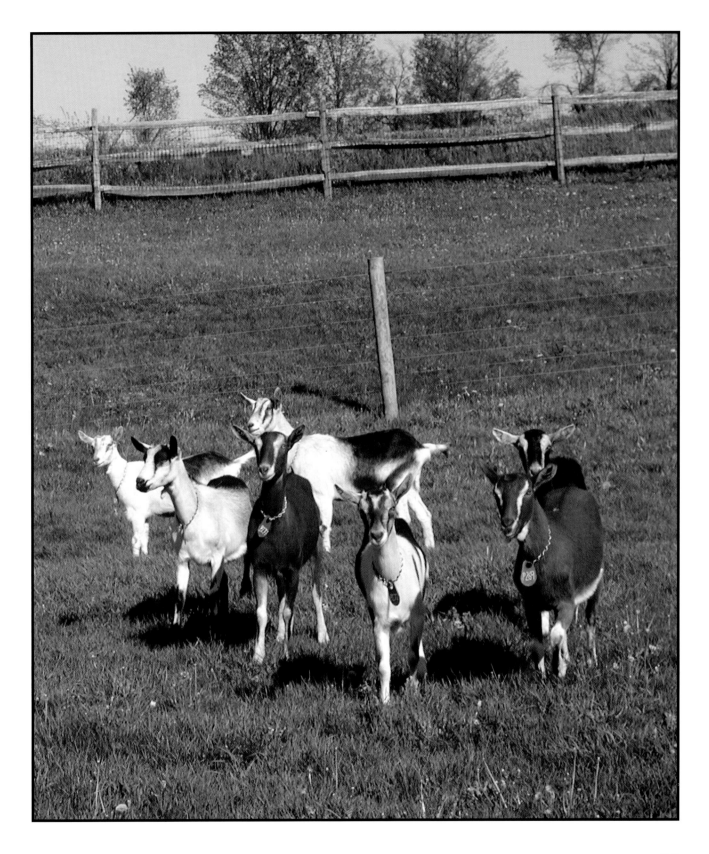

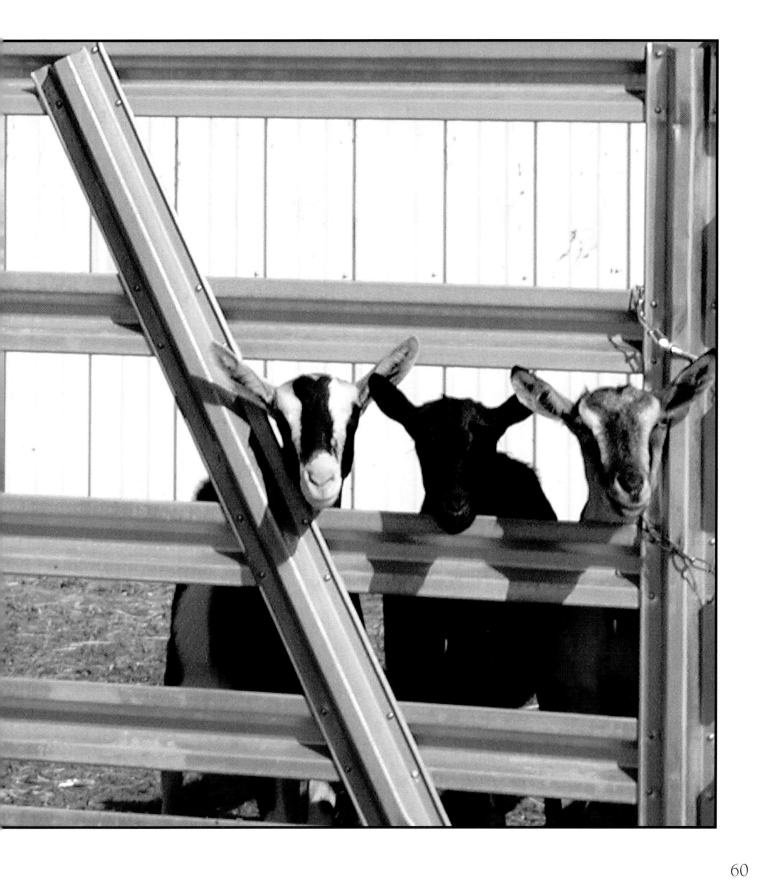

This is Bialystock ("The Producer") taking a short break from his chores. He is totally committed to his job, which is to produce as many kids as he can, thus insuring that his genes will be passed on to future generations of goats.

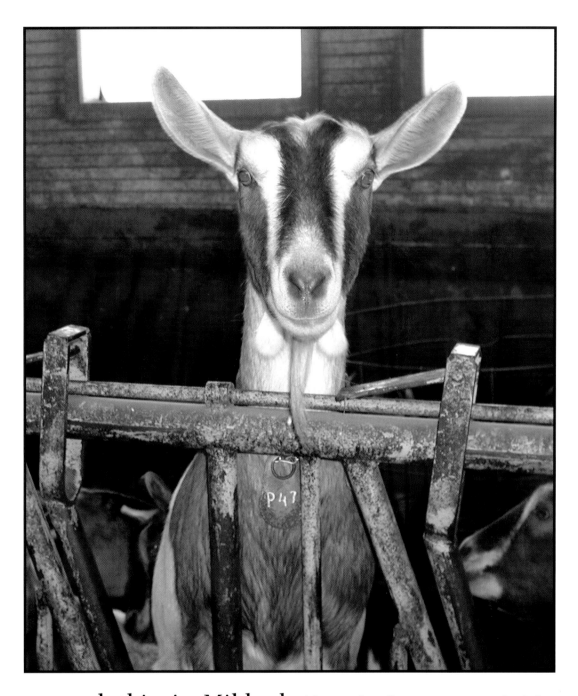

. . . **and this is Mildred**. After a brief encounter with "The Producer" in December, she produced two kids in the spring. Mildred was born and raised on the Coach Farm - as was her mother and all her grandparents going back more than fifteen generations. We provide her with room and board, a generous health plan and Day Care for her kids, in return for which she is pleased to give us her milk . . .

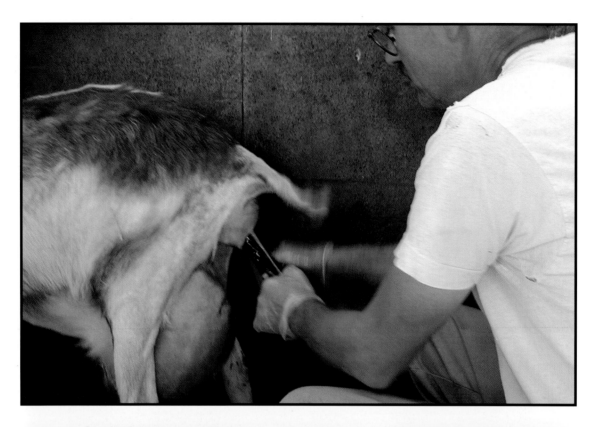

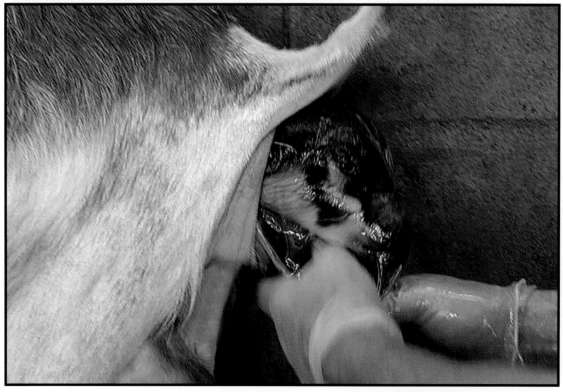

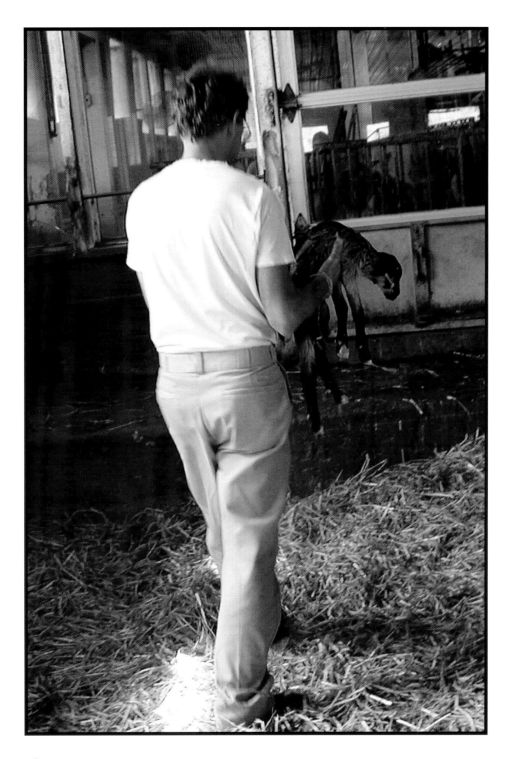

Coming out party. There are several hundred kids born here each year. This one needed a helping hand. Most of them don't.

New born kids are human in scale, weighing in on an average between five and eight pounds. Twins are common and there are occasional triplets. Before moving into the nursery, newborn kids are kept separate for the first 24 hours. They get their first two feedings from a baby bottle.

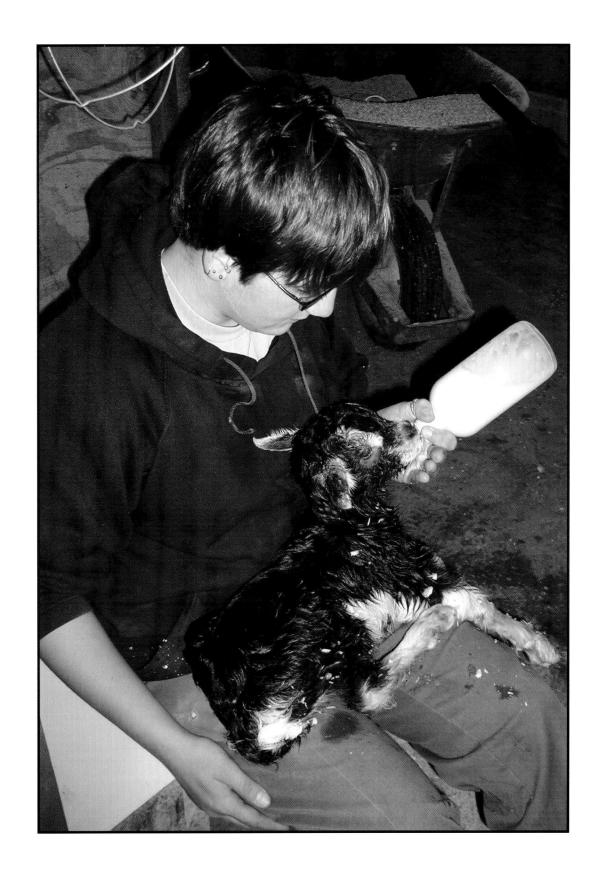

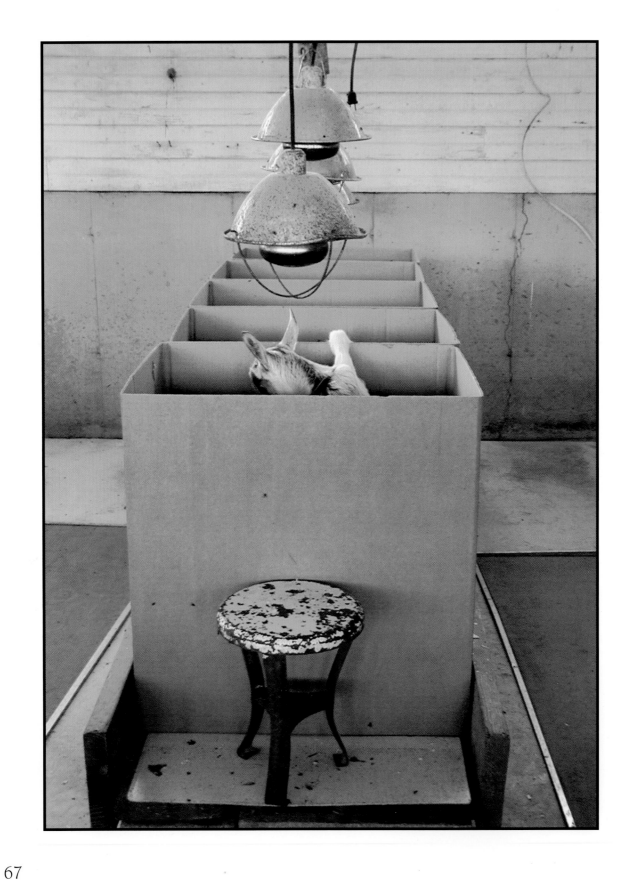

Born only a few hours ago, and still without a name, this kid can already stand up and walk around and has just taken her first free-standing pee.

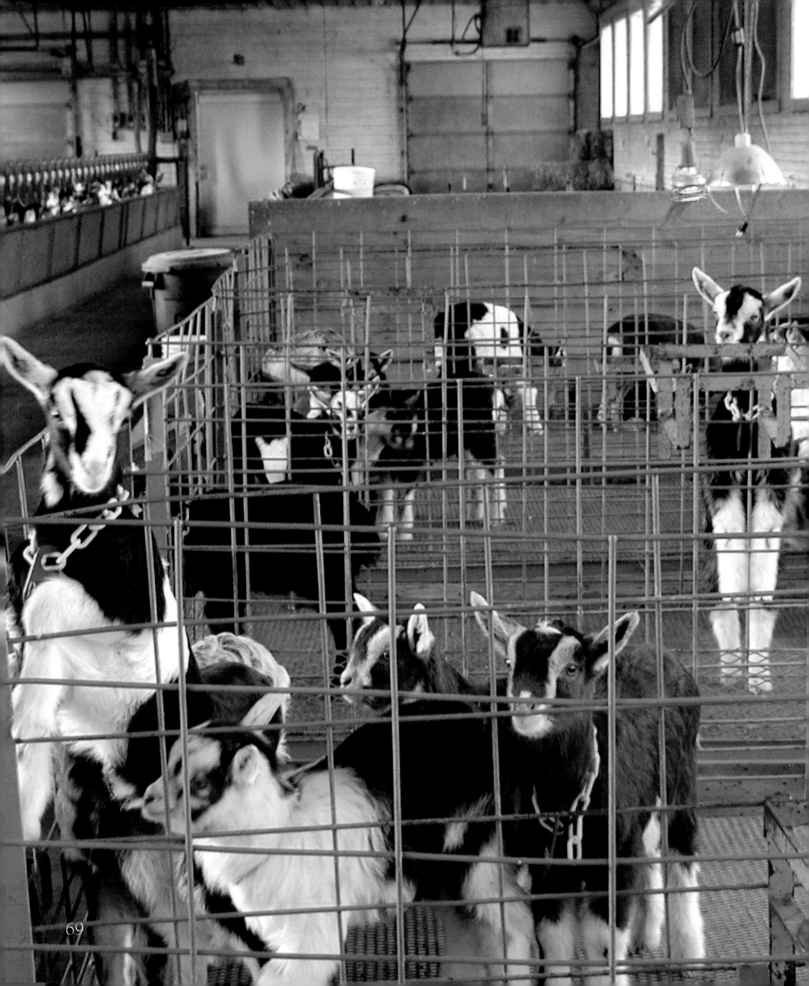

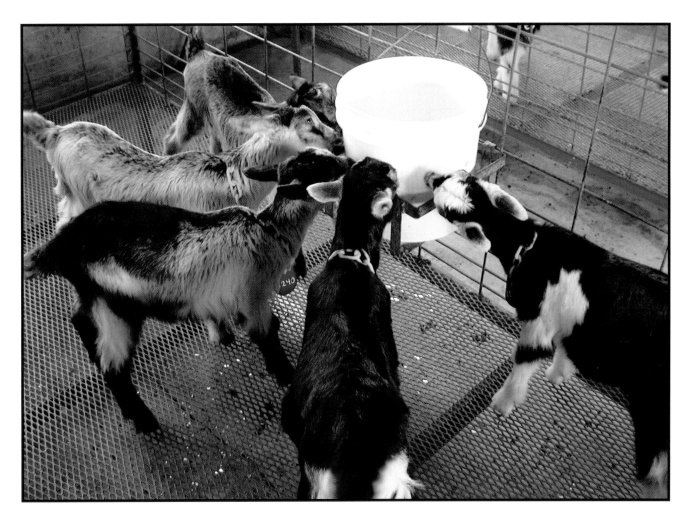

The Nursery. Newborn kids spend their first few weeks here, six to a crib, nursing from a communal tub of formula while Mom's milk is being made into cheese. The kids mature rapidly, and within six or seven weeks, they are eating solids and are ready to move on to Junior High School.

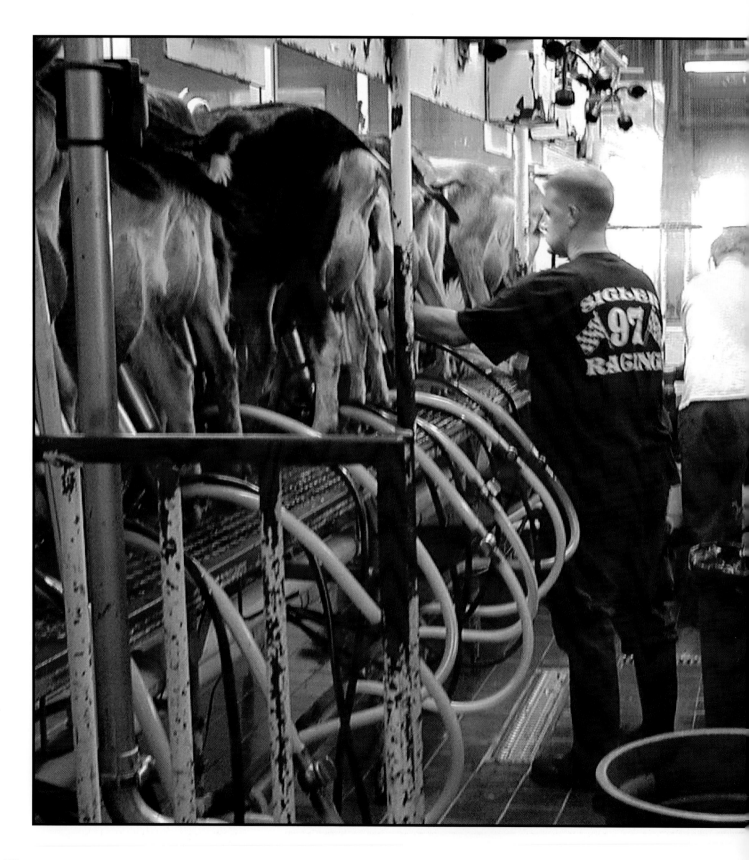

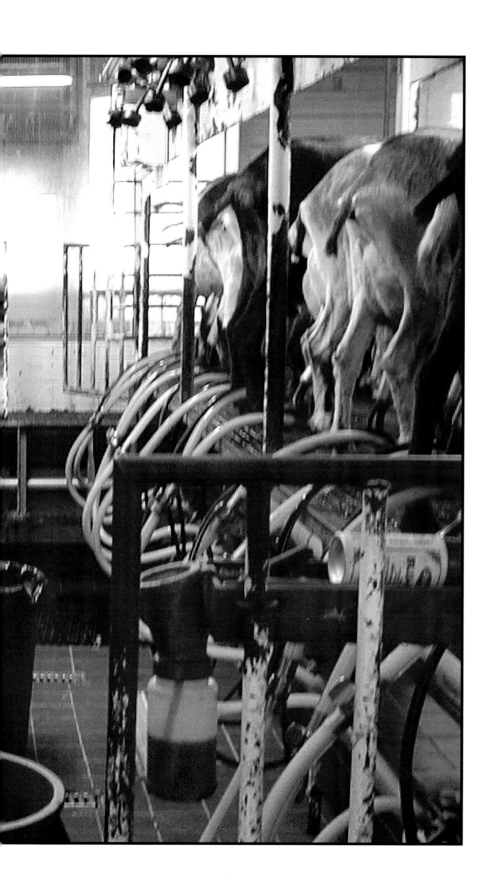

In the milking parlor.
The goats file into the milking parlor twice a day to deliver their milk – then hurry back to their barns where they are rewarded wth a tasty supplement of grains. The milk is accumulated in refrigerated holding tanks and then pumped directly into the creamery. Compared to cows that can give you upwards of ten gallons of milk a day, goats average less than one gallon a day.

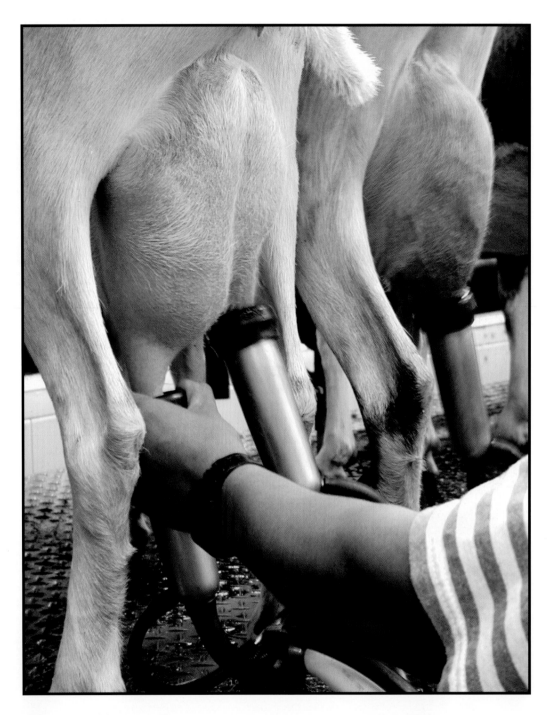

The milking devices duplicate the sucking action of a nursing kid, releasing the flow of milk and relieving the doe of the pressure that has built up since the previous milking.

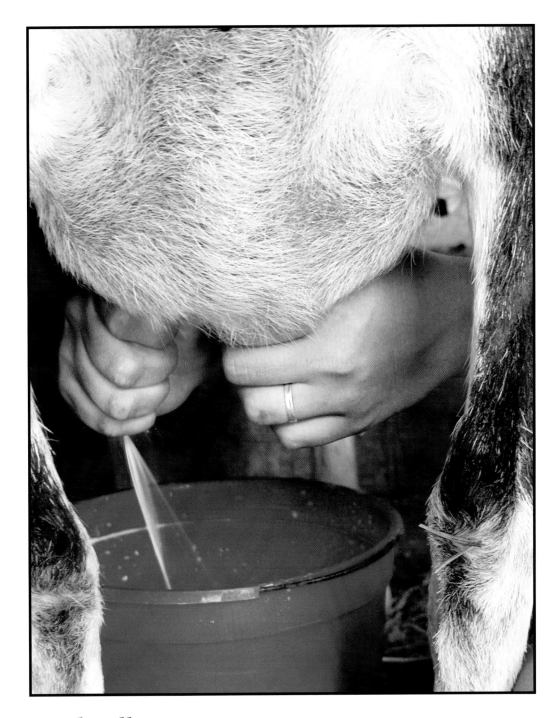

Hand milking. There are still occasions when we have to do it the old-fashioned way – into a bucket.

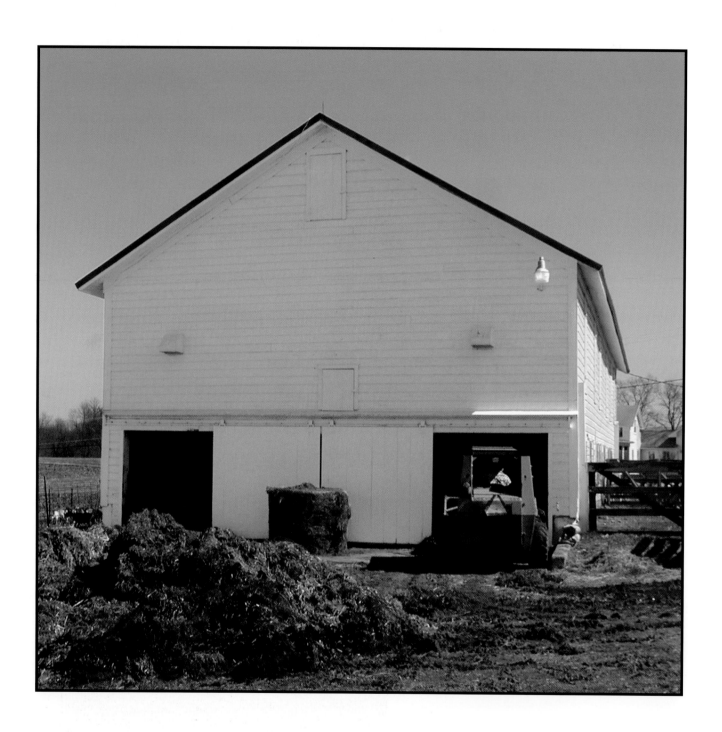

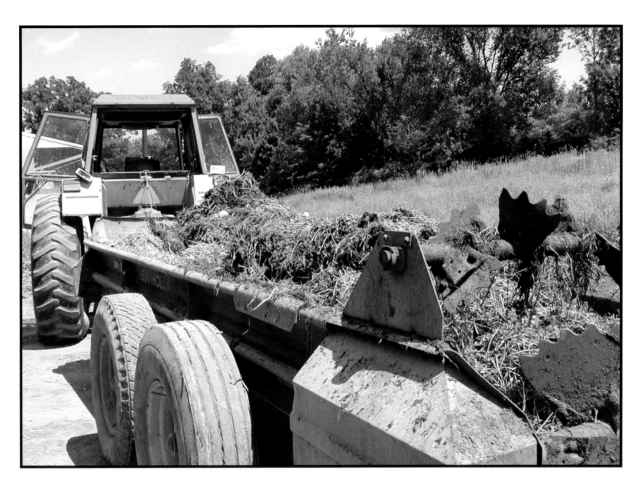

The manure spreader.

Removing manure from the barns and spreading it out on the fields is an important part of what keeps a working farm working.

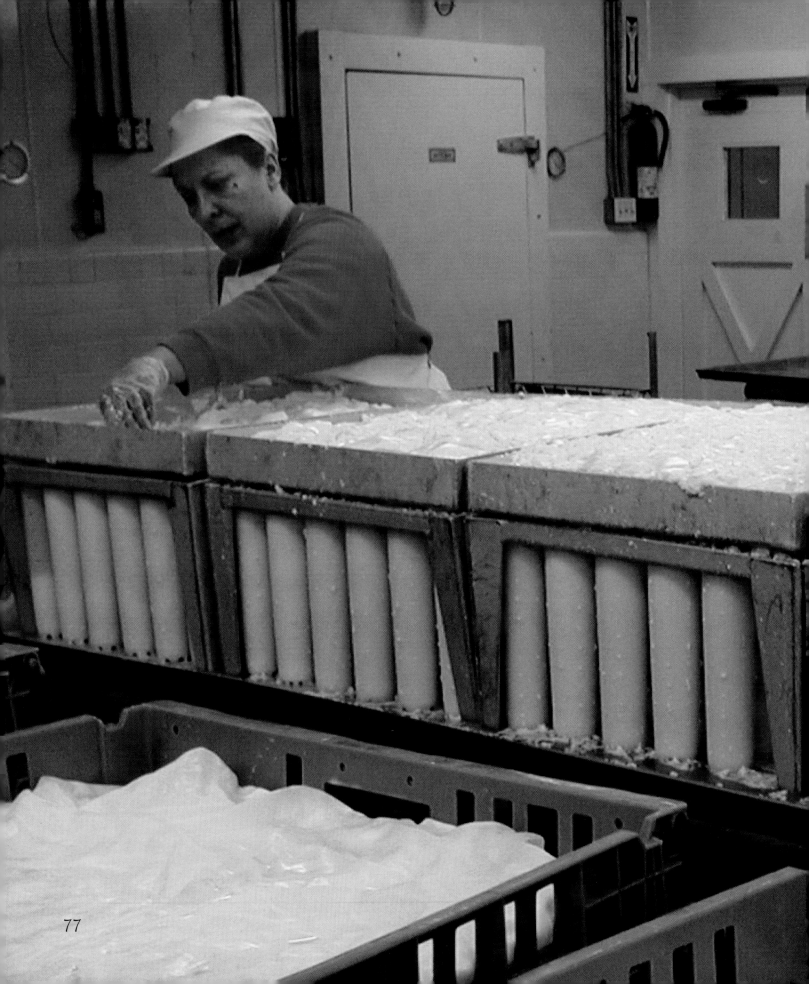

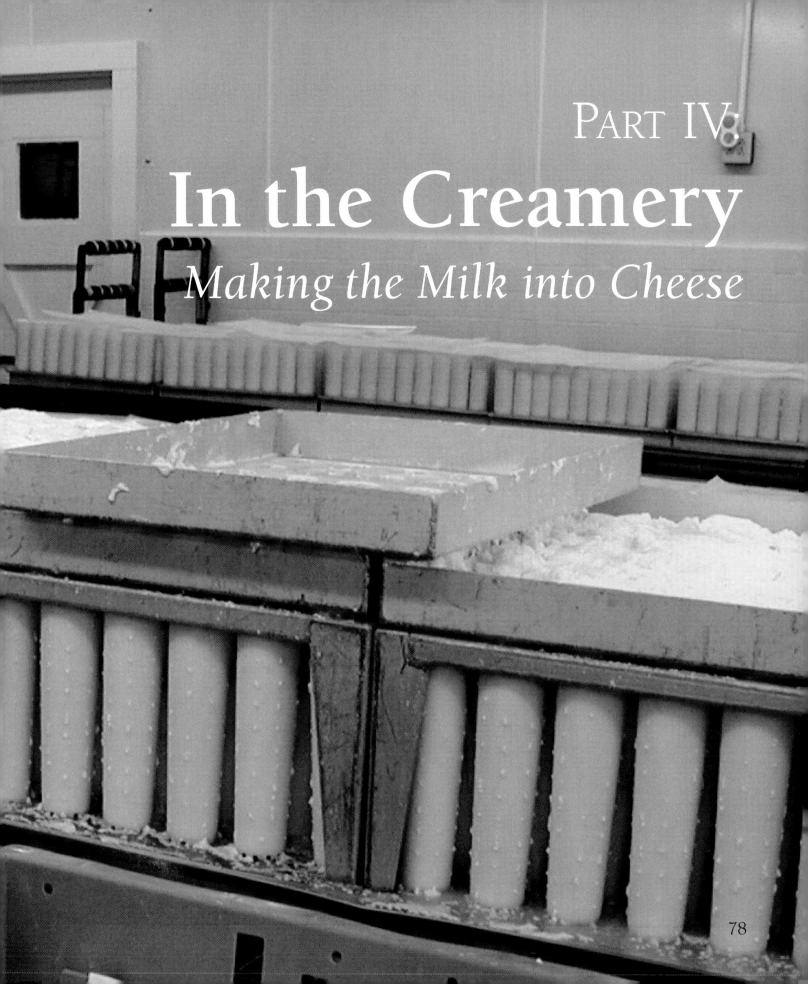

PART IV:
In the Creamery
Making the Milk into Cheese

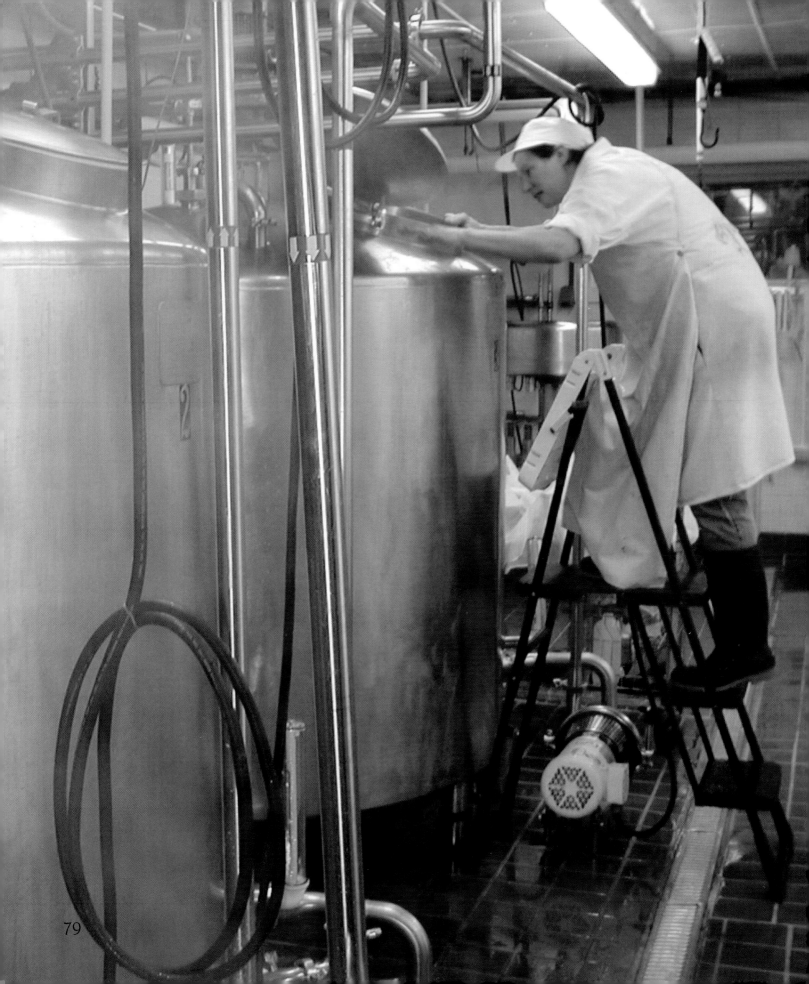

The stainless steel vat pasteurizers hold 2,700 pounds of milk. The temperature is held at 150 degrees for thirty minutes, killing all the "bad bugs" after which the cultures (the "good bugs") are added. The temperature and time on each batch are automatically recorded on a chart that is examined regularly by State Agriculture inspectors.

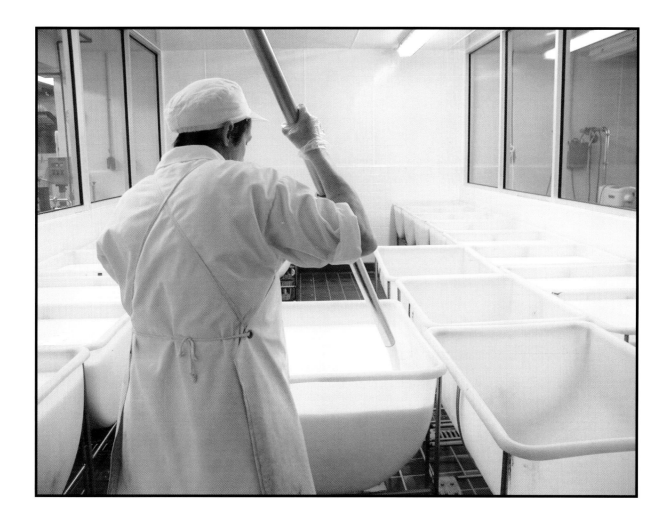

The milk is then pumped over into the incubating room where it remains overnight. By the following morning the culture has done its work, and there are eighteen tubs of curdled milk ready to be wheeled into the draining room where the curd will be separated from the whey and made into cheese.

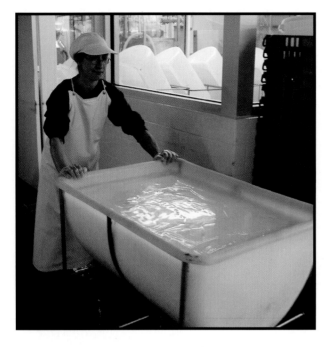

Hand ladling. The curd is gently lifted out of the tubs and slipped into individual draining molds, where it will remain overnight – the whey draining out of the tiny holes in the mold. The object of hand ladling is to retain as much as possible of the curd's natural texture and flavor, which is what sets artisanal goat cheeses apart from the more common factory-produced goat cheeses found in the marketplace.

The following morning the 10 oz. logs are taken out of their molds.

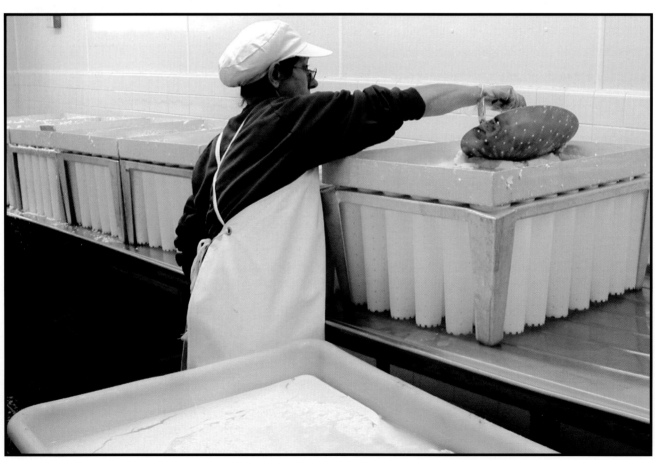

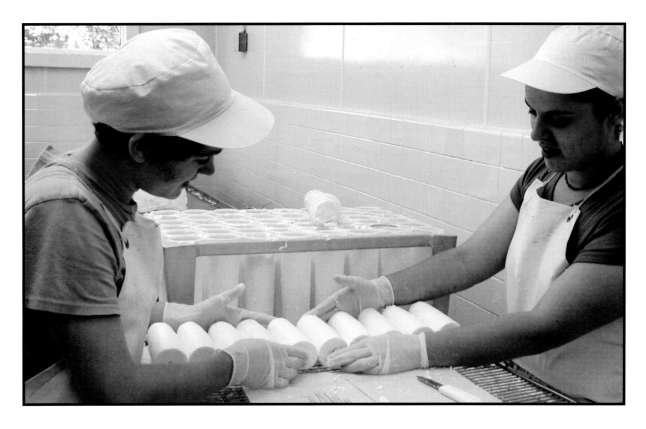

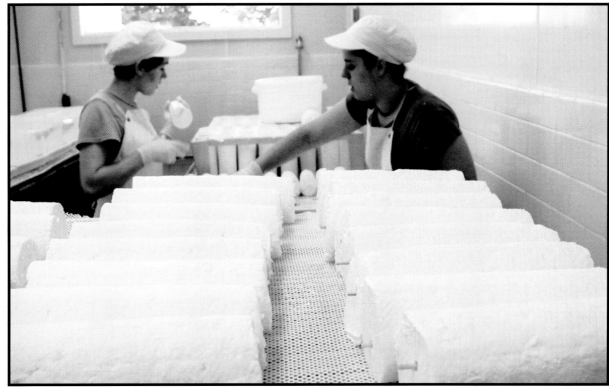

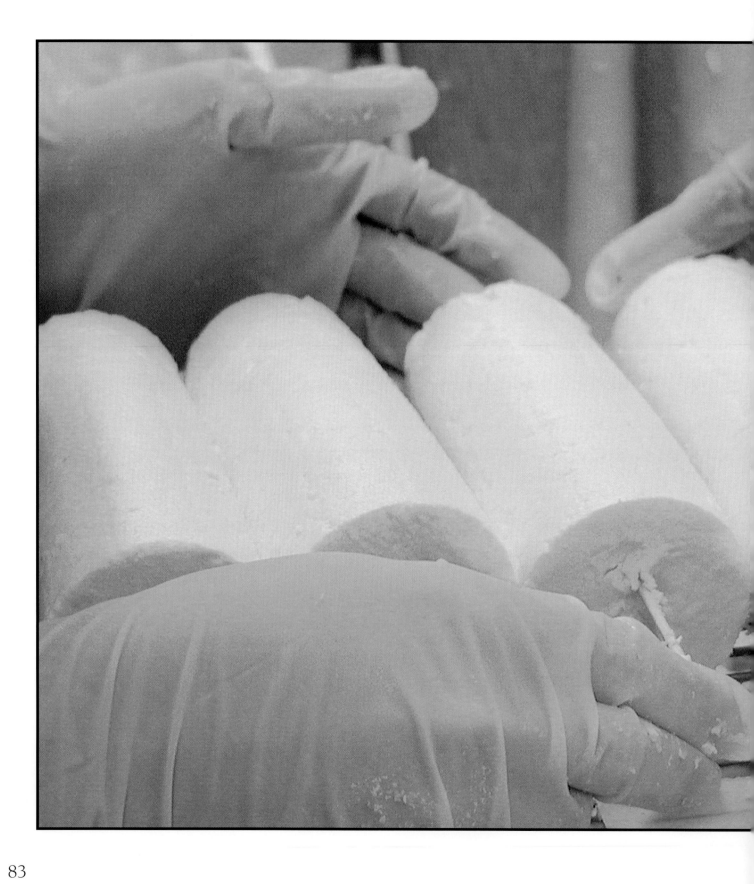

A wooden skewer is inserted in each log in order to hold it together.

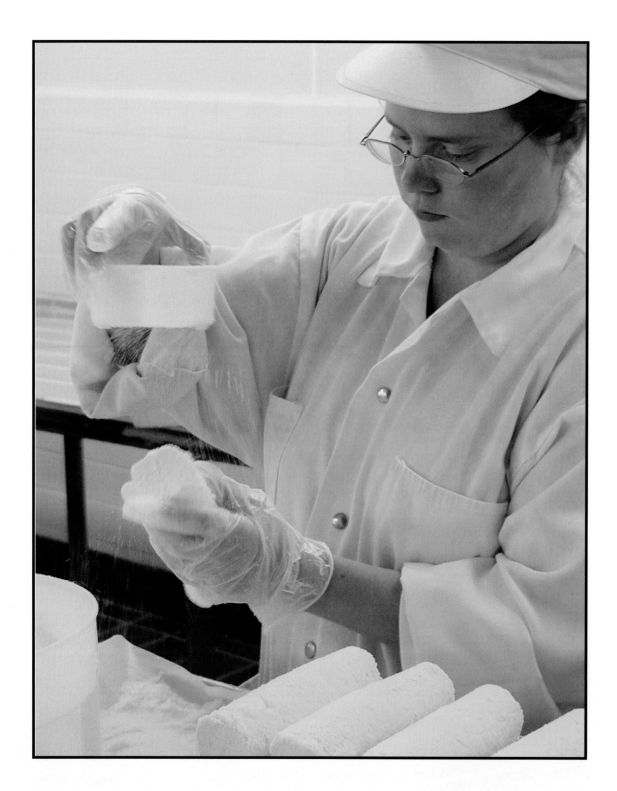

The cheeses are lightly salted before being put on racks and moved into the cooler. The salt enhances the flavor and also acts as a natural preservative.

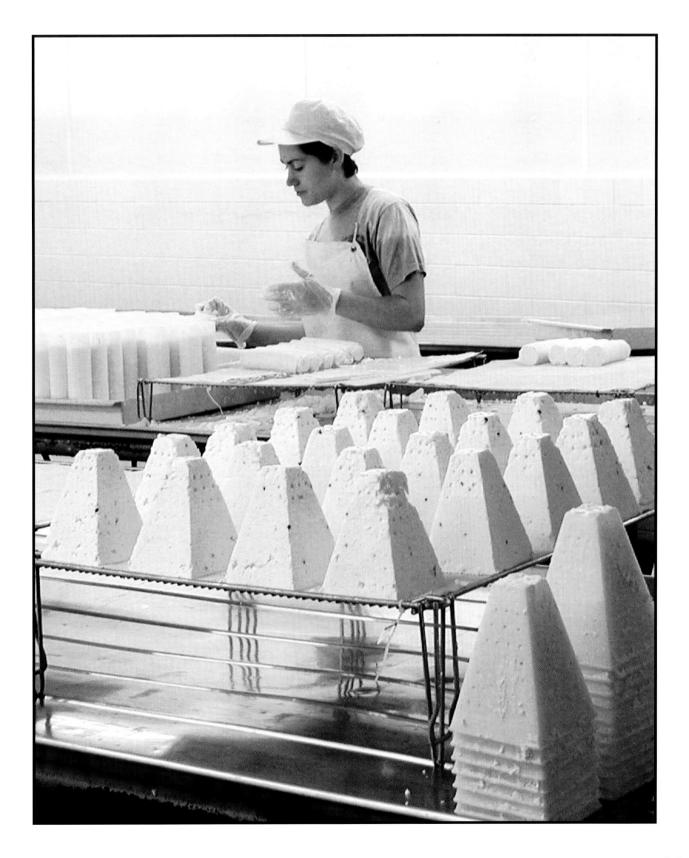

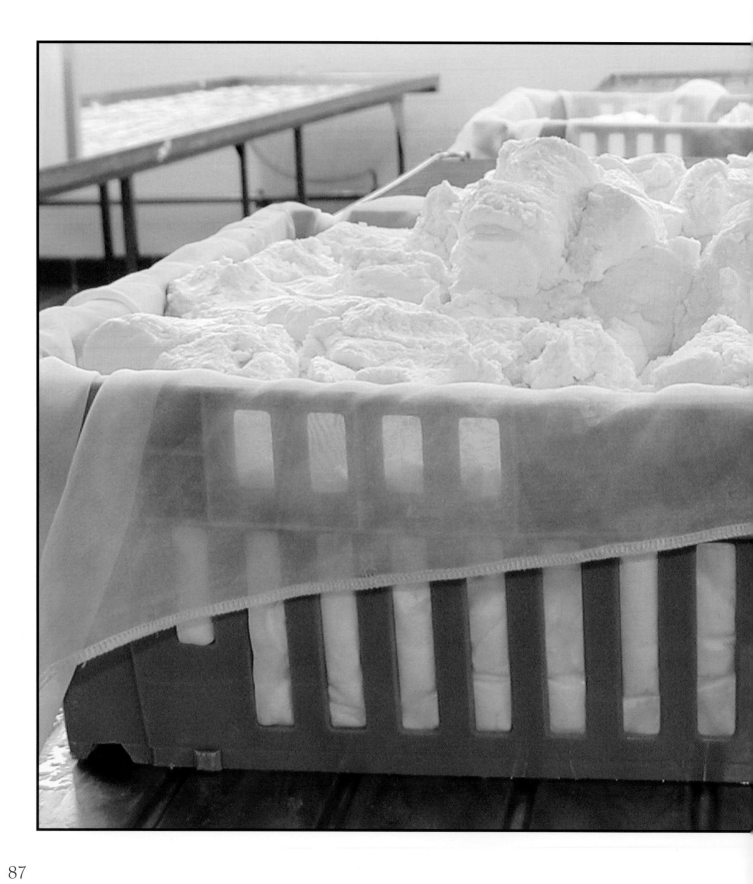

Fresh curd is sold in bulk. It has the consistency of a Ricotta and is put up in 5 lb containers.

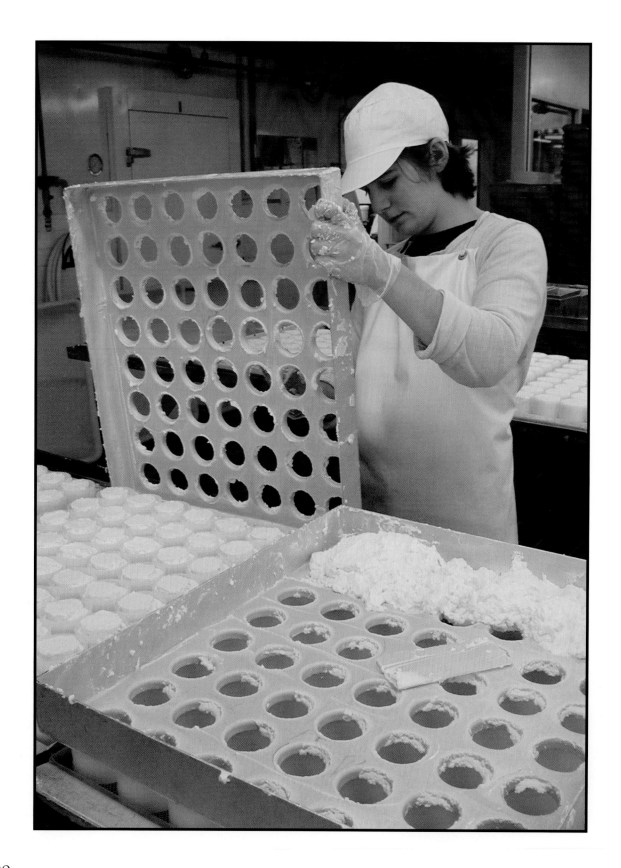

89

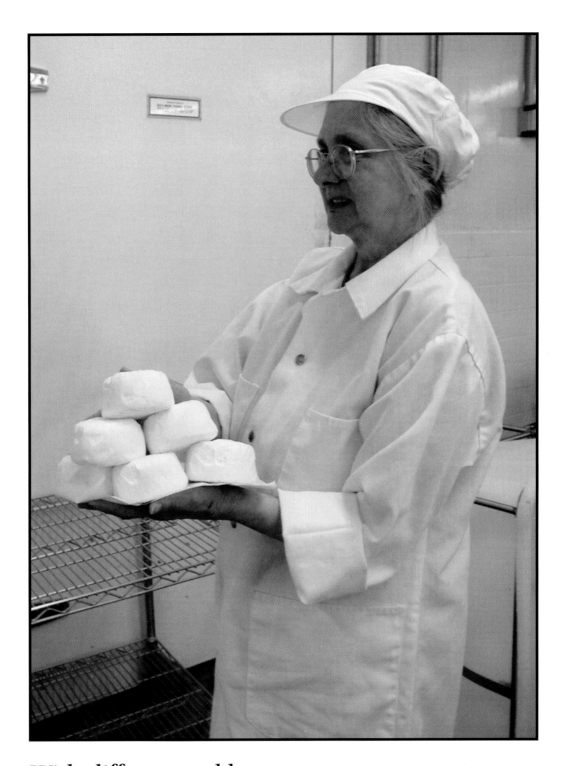

With different molds the cheeses can be produced in many shapes and sizes. Some will be sold fresh within only a few days of the milking. Others will go into the curing rooms to age.

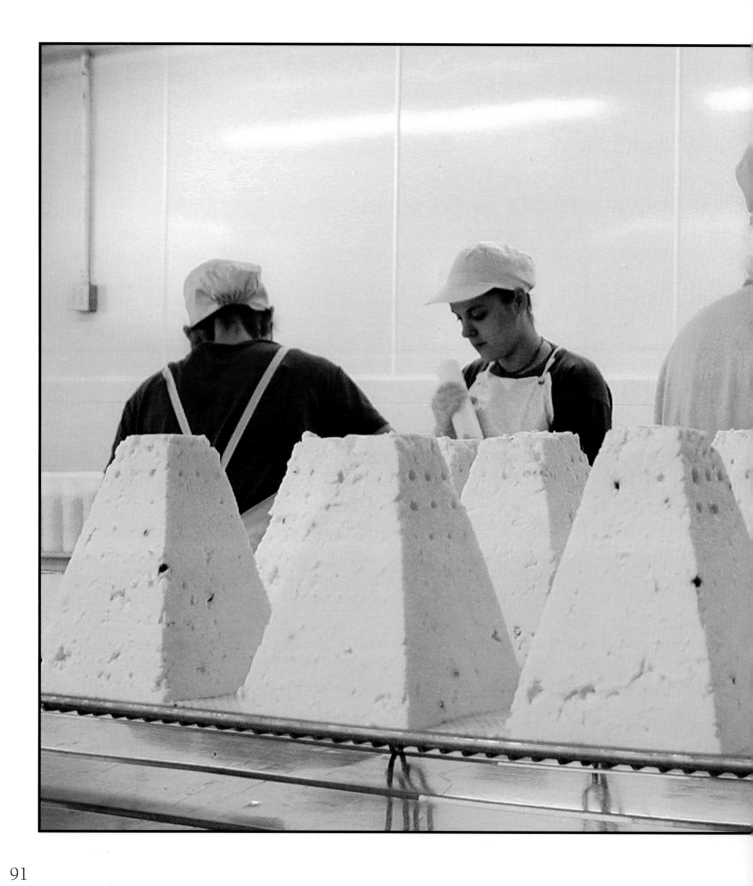

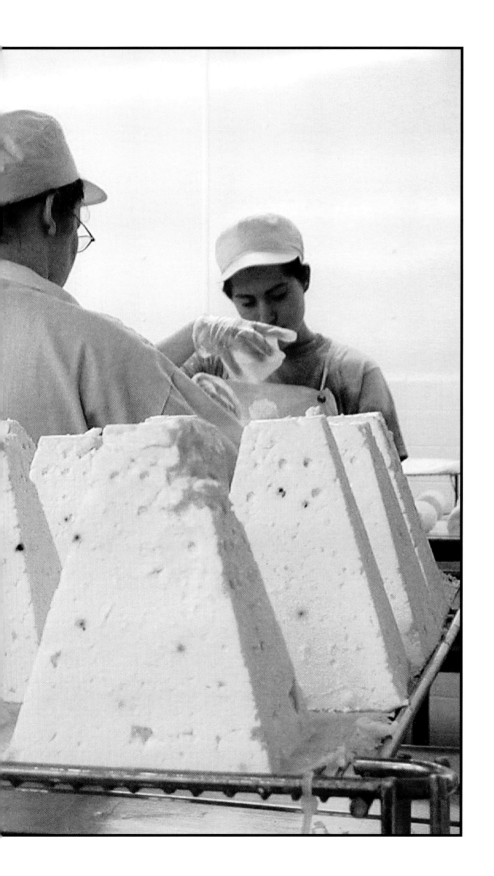

These "pyramids" will be moved into the curing room where they will remain for three or four weeks, developing the edible white rind that distinguishes this classic cheese.

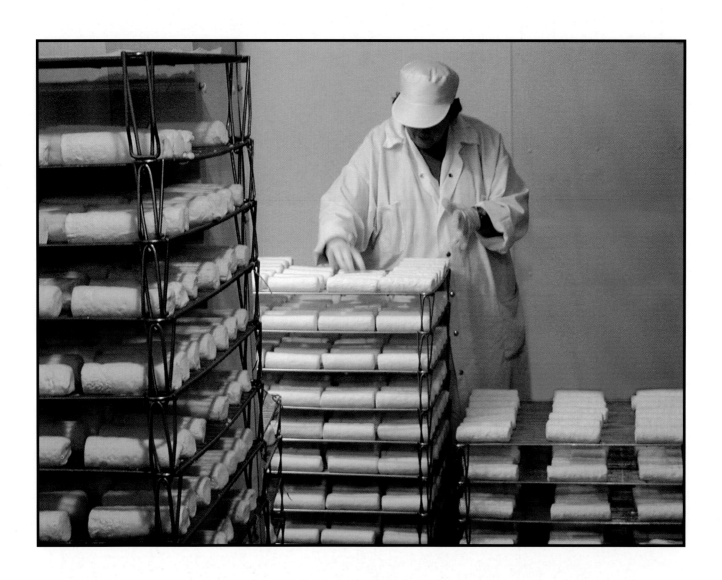

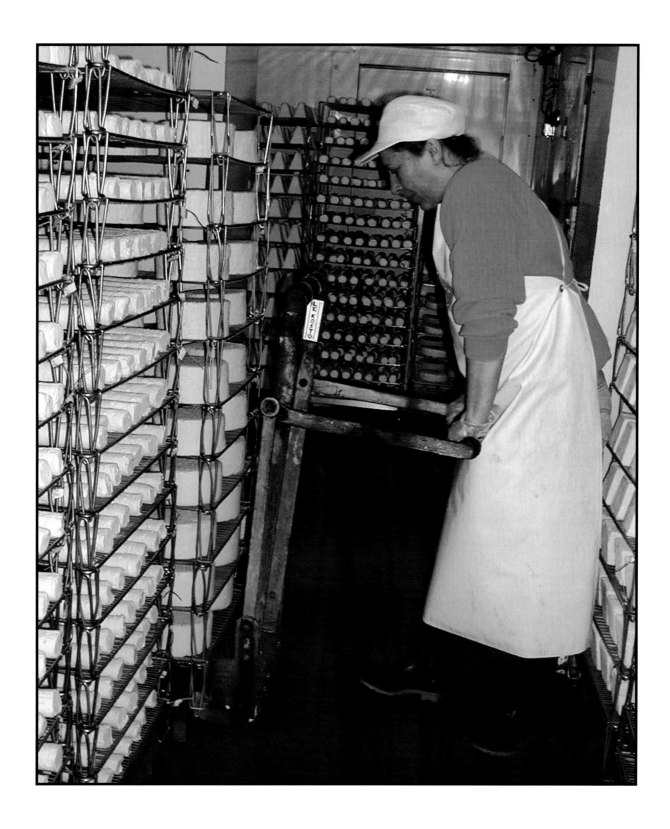

The curing room. These cheeses, in a variety of classic shapes and sizes, will spend three to four weeks here under very carefully controlled conditions. As they age, they give up their moisture and develop more "character."

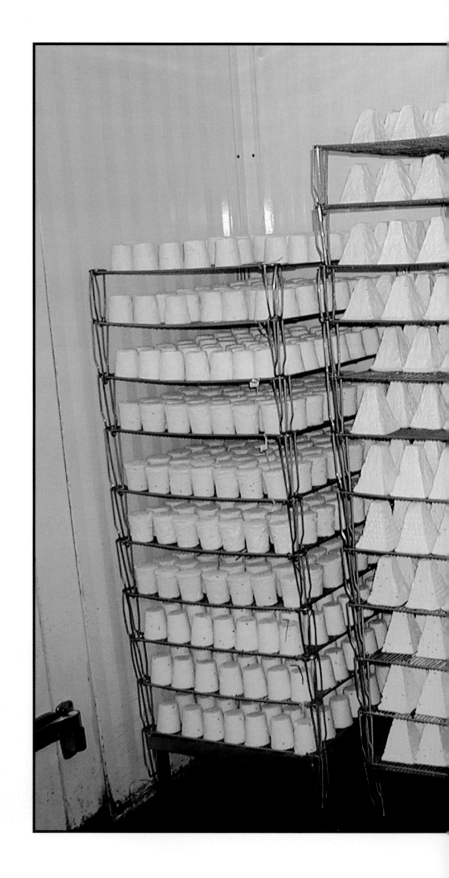

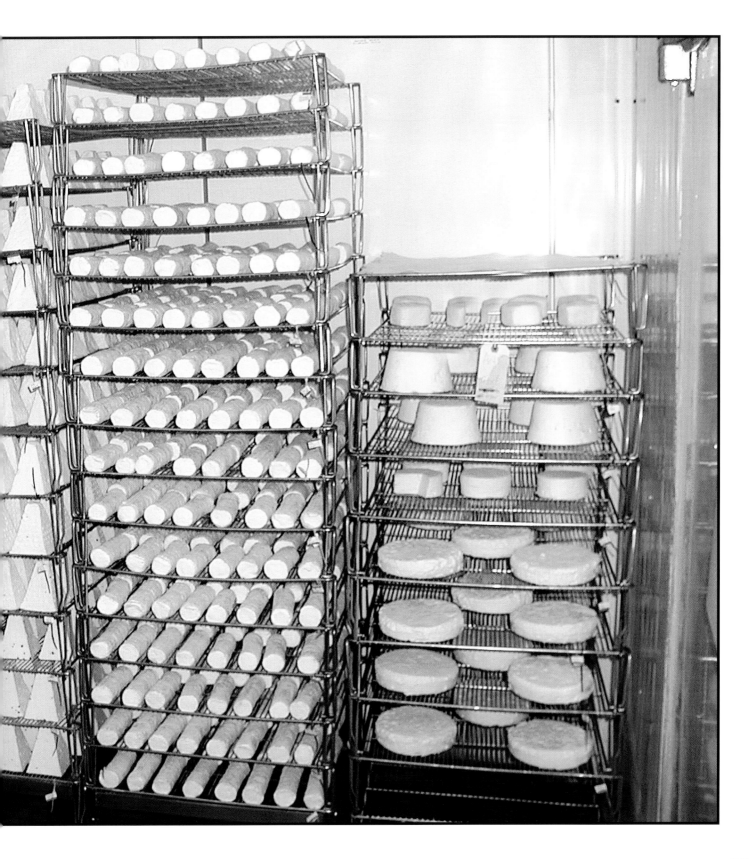

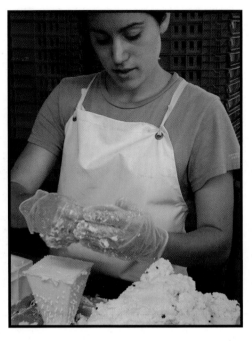

Processing and wrapping these cheeses is all done by hand as the small batches do not lend themselves to conveyors or other mechanical equipment.

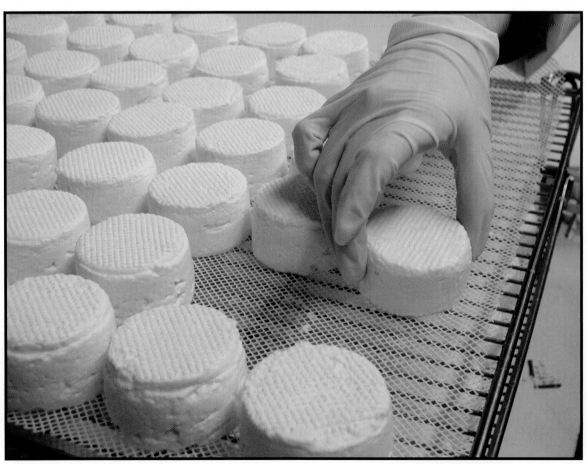

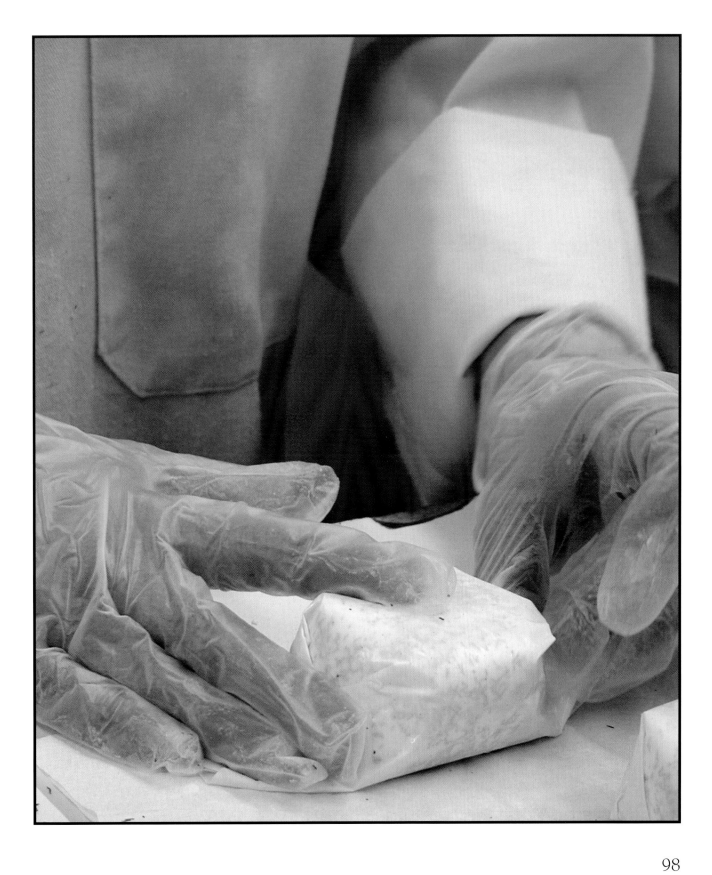

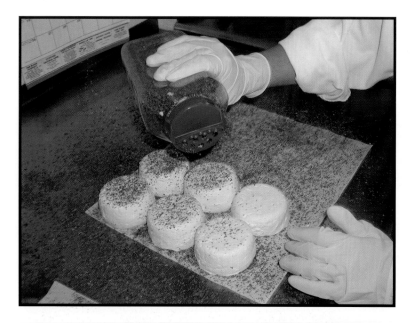

Some of the cheeses are rolled in a variety of herbs, and, when wrapped, must then be identified with the appropriate sticker.

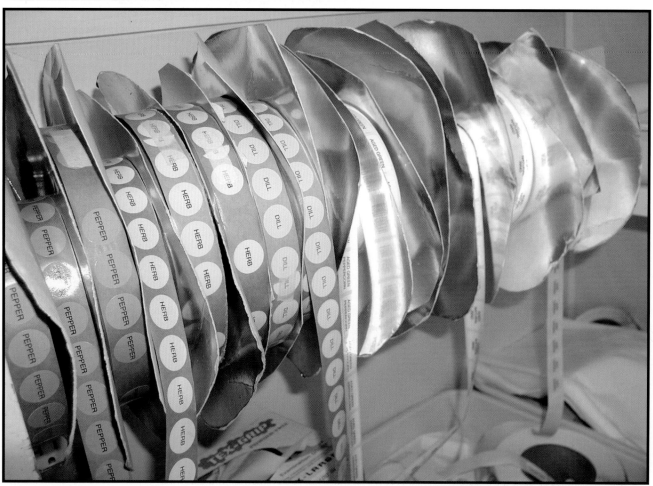

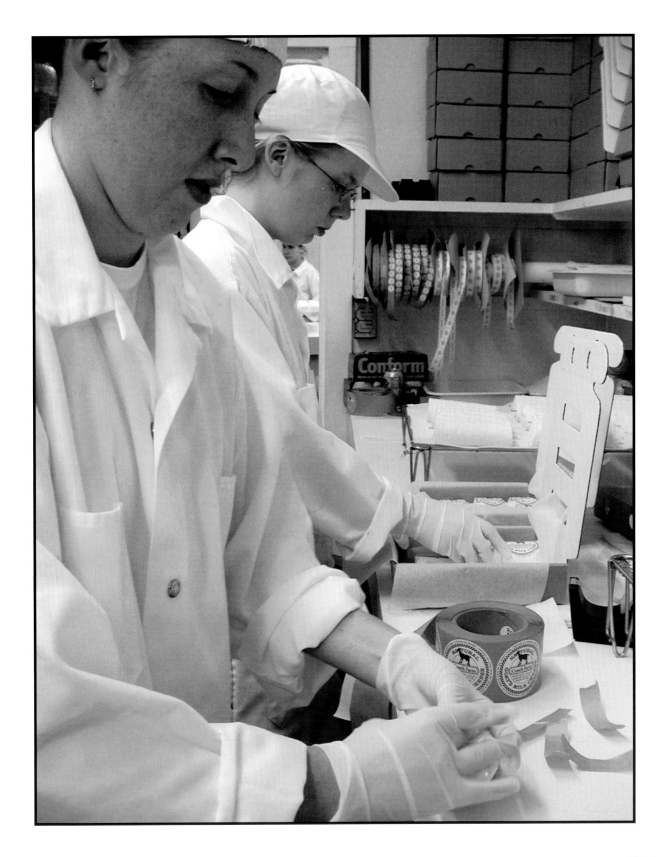

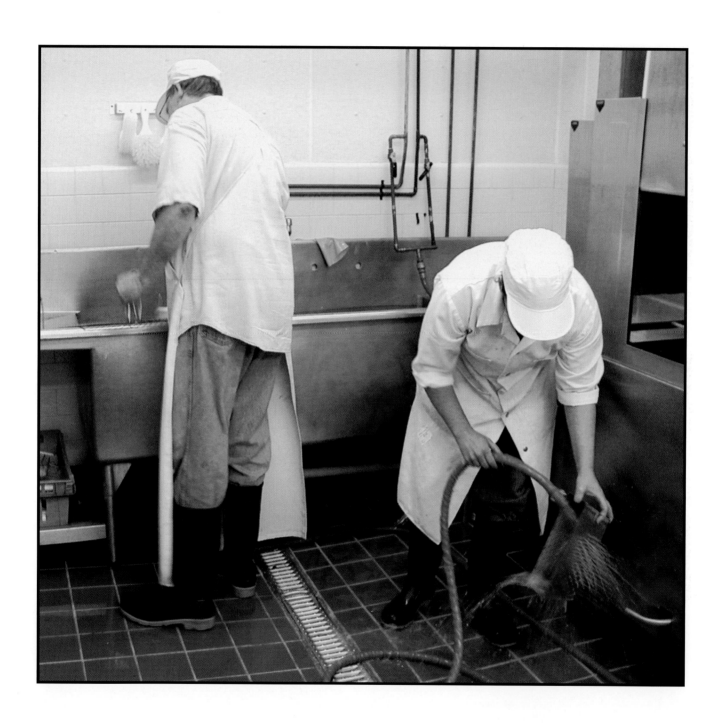

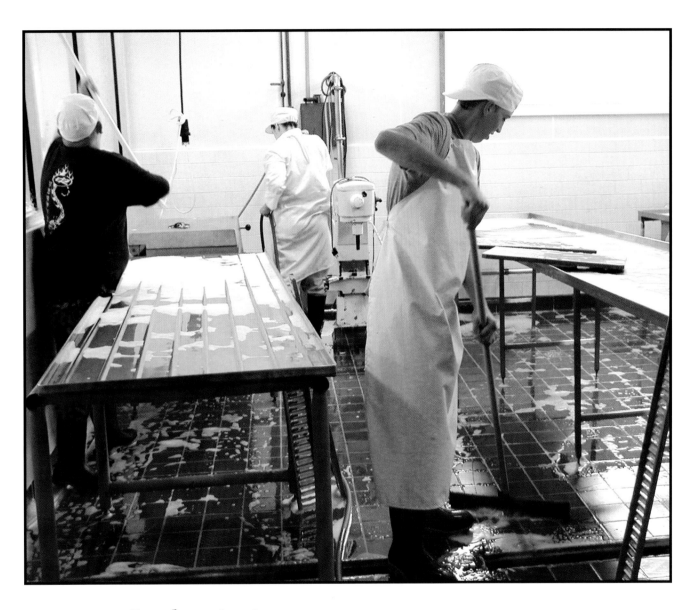

Good sanitation is absolutely essential to the production of good cheese, and more time is spent scrubbing the place down than actually making the cheese.

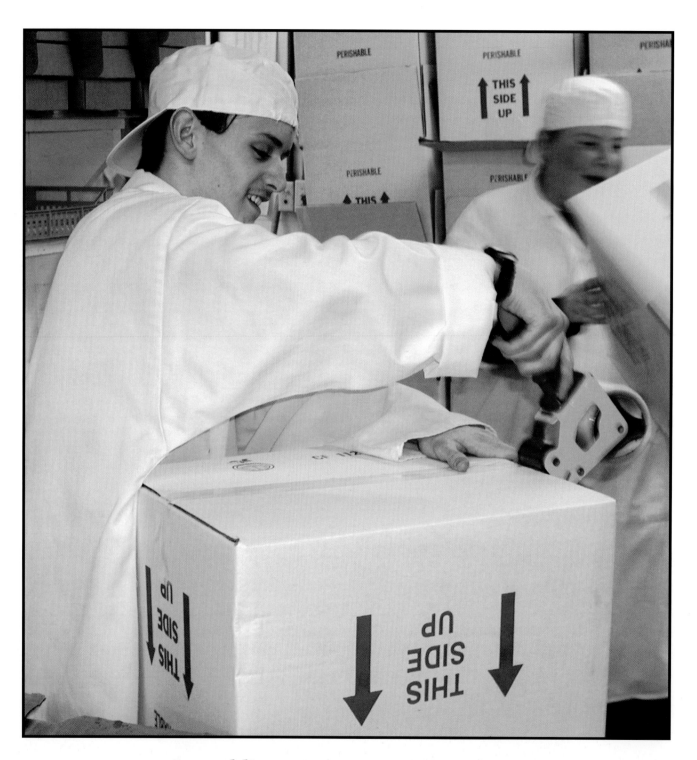

Assembling cartons is done after school by high school students who seem to prefer it to doing their homework.

The Farm office coordinates the many essential functions of an operating business, from taking the orders to scheduling their delivery – and everything in between.

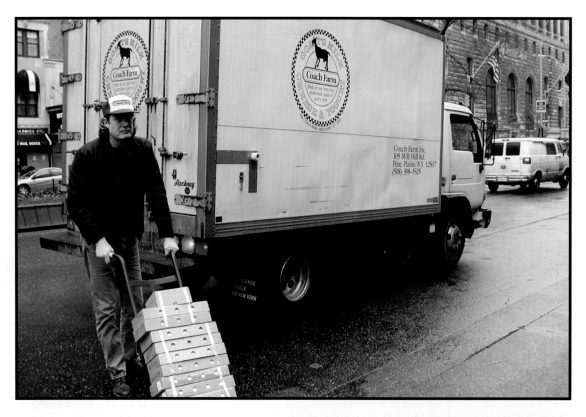

The truck leaves the Farm before dawn to avoid the rush hour and makes deliveries to restaurants and markets throughout the city. It is not unusual to pick up a parking ticket or two along the way.

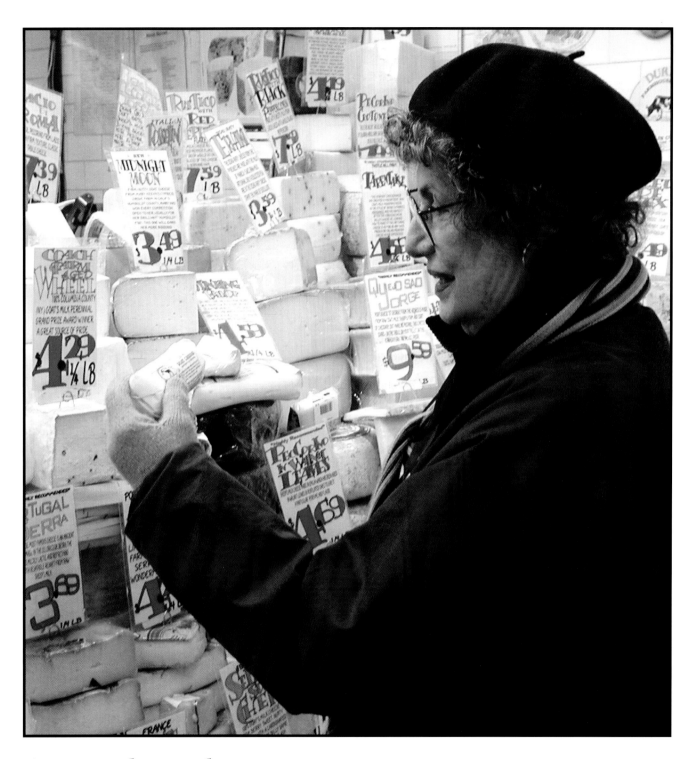

A great cheese department, like this one, offers a wide selection of aged cheeses brought in from all over the world. They also carry a fresh domestic goat cheese that was made that week and delivered to them that morning directly from the Farm.

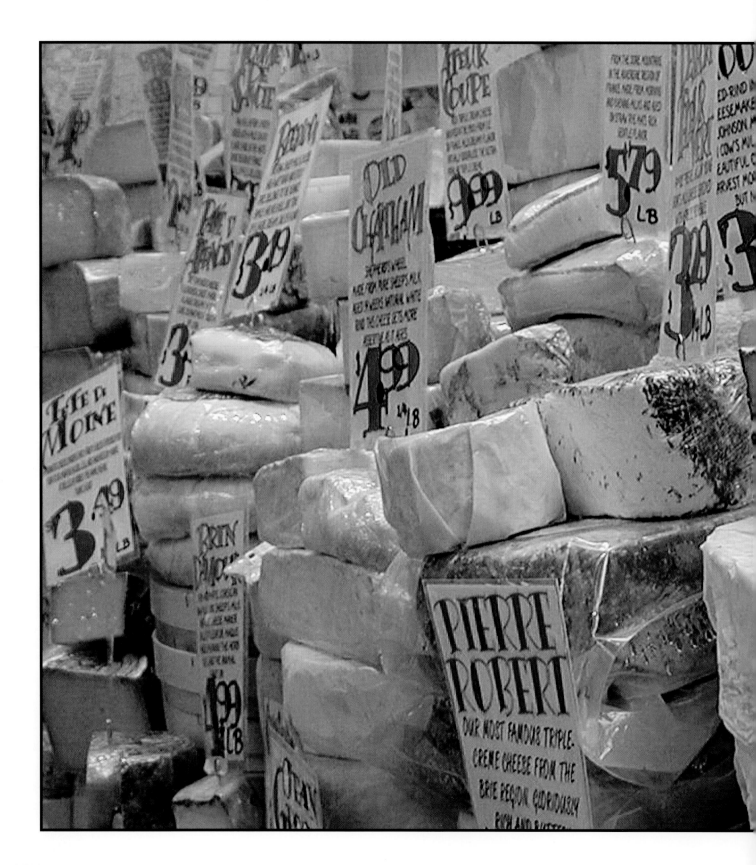

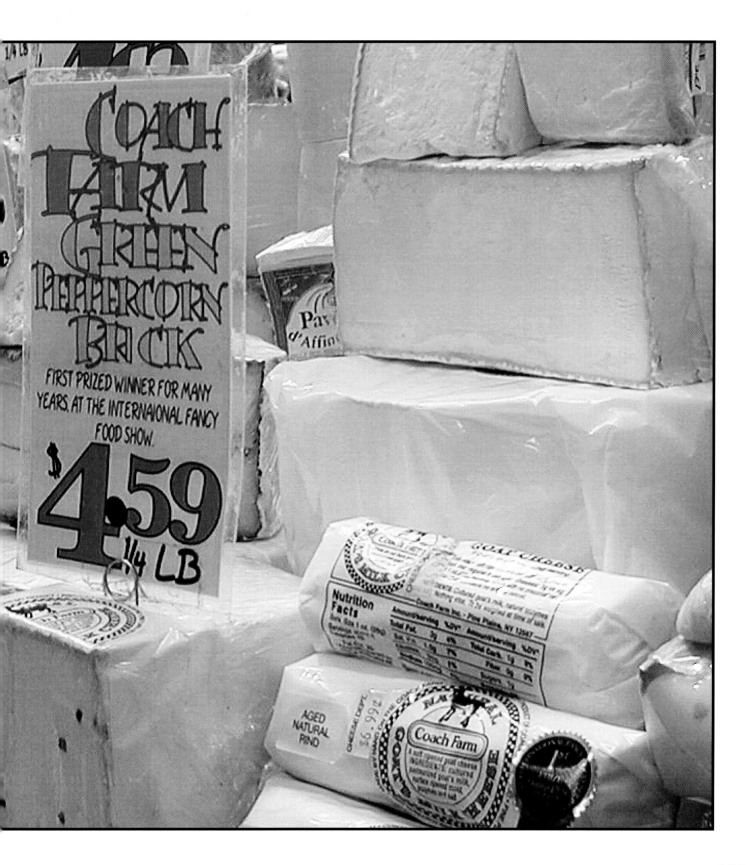

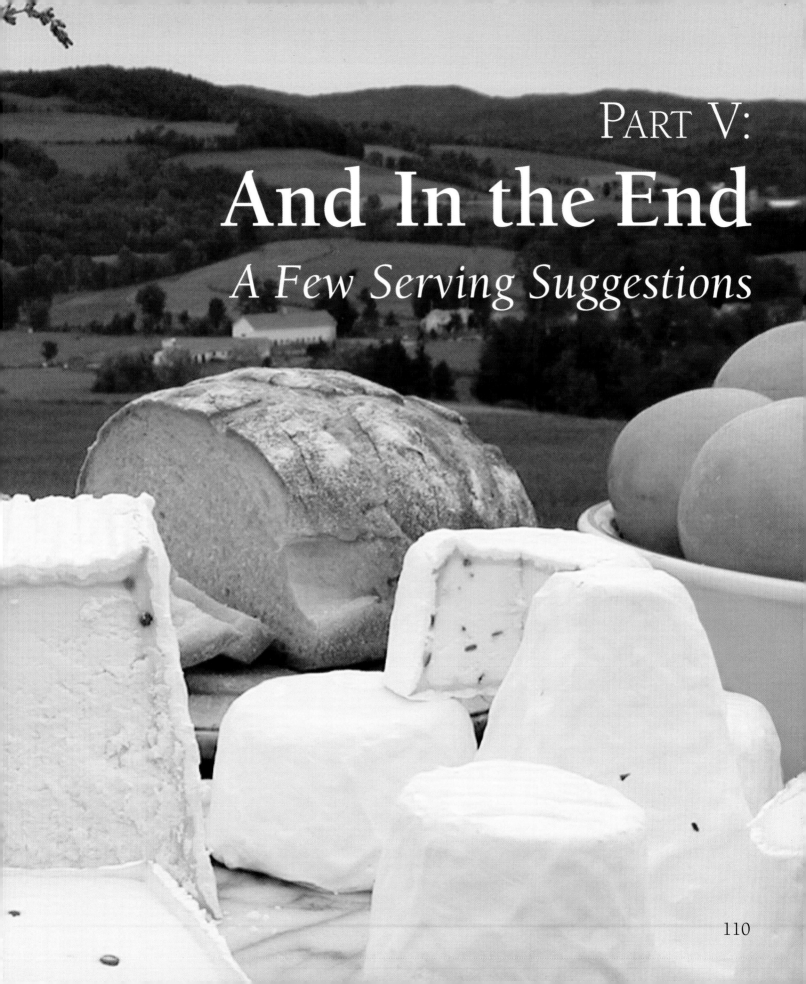

PART V:
And In the End
A Few Serving Suggestions

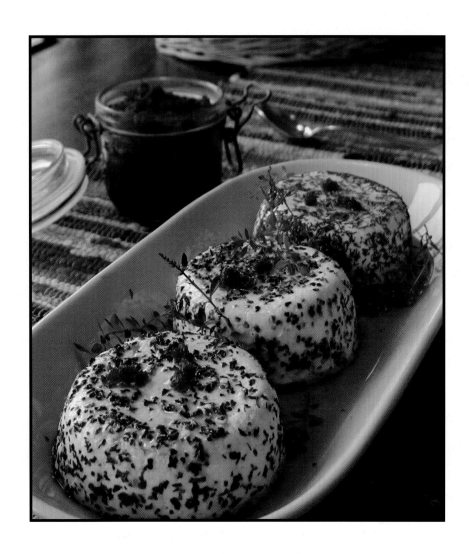

A Few Serving Suggestions

In theory, at least, goat's milk lends itself to as many different types of cheese as does cow's milk. In practice though, it is the fresh goat cheeses, commonly referred to as "chevre," with which we in this country are most familiar. Coach Farm makes this cheese in several different shapes and sizes, and there must be dozens of ways to serve and enjoy it. Having tried a good many of them ourselves, we are pleased to recommend a few of our personal favorites. (WARNING: A regular diet of goat cheese is habit-forming and can lead to serious addiction).

As a sandwich. Open-faced or sandwiched between two thick slices of crusty country bread, fresh goat cheese goes great with a number of different warm toppings such as caramelized onions, sun-dried tomatoes or roasted garlic or else, simply sprinkle the cheese lightly with herbs (thyme or dill) and drizzle with a good virgin olive oil. Start with a leek and potato soup (hot or cold), then bring on the sandwiches with a tossed green salad on the side, and that should take care of lunch.

With cocktails. Place fresh or aged goat cheese on thin baguette slices, drizzle with virgin olive oil and place under the broiler for a few minutes. Remove, lay them out on a platter and sprinkle lightly with herbs. Then, bracing yourself for the compliments, start passing them around while they are still warm.

On a salad. Place a one ounce piece of fresh goat cheese on top of a single serving of salad that has been tossed with a good salad dressing (our secret recipe: 3 parts virgin olive oil, 2 parts balsamic vinegar, a small dollop of Dijon mustard and shake well). Be sure to pour a bit more of the same dressing over the cheese. Mixed greens are very popular these days, but we urge you to try hearts of Romaine, which is real crunchy and holds the dressing well. For a treat, put the cheese under the broiler for a few minutes and place it on the salad while it is still warm.

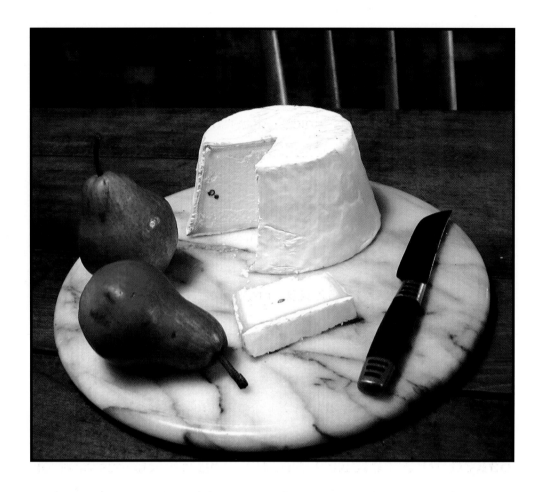

As a cheese course. A selection of cheeses, presented on a large platter or cutting board, is a nice way to wind up a great meal, and no cheese course is complete without at least one goat cheese. For something special, you might want to try a selection consisting of only goat cheeses, fresh and aged, or perhaps focus on a single large wedge of aged goat cheese. Whatever you do, the cheese course should always be accompanied by a good crusty country bread or bagette. If you are offering a variety of cheeses, it is a good idea to provide a bunch of seedless grapes to freshen the palette between tastings. A basket of Granny Smith green apples or a couple of ripe pears on the side adds a nice touch.

With the "correct" bottle of wine. Many people, *Food and Wine* subscribers in particular, go to great lengths in their efforts to pair goat cheese with just the correct wine, and we are often asked our opinion on this subject. After repeated trials, we have come up with two recommendations: red wine and white wine. Though we are inclined to favor a full-bodied Côte du Rhône, the fact is that goat cheese goes great with any good dry wine - red or white. So put aside your concerns. In our book, at least, they are equally "correct."

Crumbled over pasta. Fresh goat cheese added to your pasta can take it to new heights. Some people like to blend it into the sauce. We much prefer it crumbled over and then tossed with the pasta or, better yet, served at the last moment, with a hunk of parmesan (the real thing if you can get it) and a grater.

Baked in a chicken breast. This is a delicious variation on the classic chicken "Cordon Bleu." Place a piece of fresh goat cheese, a piece of ham (or sun-dried tomato) and a sprig of parsley onto a flattened chicken breast half. Fold it over, coat it with bread crumbs, brown it in butter, and then transfer it to a baking pan and bake at 325° for about one hour. You can make it the day before and warm it up before serving. Or, for that matter, you can keep a few in reserve, all made up in your freezer.

In a cheesecake. Try substituting fresh goat cheese for the cream cheese or ricotta that is specified in most cheesecake recipes and don't stint on the vanilla extract and the lemon zest. We don't make this as often as we would like as cheesecake is said to be fattening.

In a beet salad. Fresh goat cheese and cooked beets have a special affinity. Crumble a portion of fresh goat cheese onto a beet salad that has soaked up your favorite balsamic vinegar dressing. Add a small amount of thinly sliced red onion and serve at room temperature. Or for a colorful effect, lay out alternating slices of red beets and white goat cheese on a bed of mixed salad greens and pour on the salad dressing.

As a dip. Fresh goat cheese makes a wonderful dip alongside a basket stacked with raw carrot sticks, broccoli, sweet peppers, fennel and endive. The trick is to thin the cheese to the desired consistency by mixing it with a little goat's milk yogurt and then adding chopped dill and cucumber or (our favorite) little bits of sundried tomatoes that have been marinated in olive oil.

Goat cheese ravioli. Next time you are making your own ravioli, try filling them with fresh or aged goat cheese – or even a combination of the two – and serve them slathered in your own, homemade pesto. (If you can make your own ravioli, you will surely know how to make your own pesto).

To conduct your own cheese tasting. First consult Steve Jenkins' *Cheese Primer* and study up on four or five interesting cheeses (including at least one goat cheese, of course). Then invite a few friends over for dinner. After dinner, distribute individual plates around which you have arranged small samplings of the various cheeses. You then direct your guests to taste each cheese in turn, working clockwise around the plate while you deliver the appropriate commentary. You should be able to do this with some authority, as you are sure to know more about these particular cheeses than anyone else at the table.

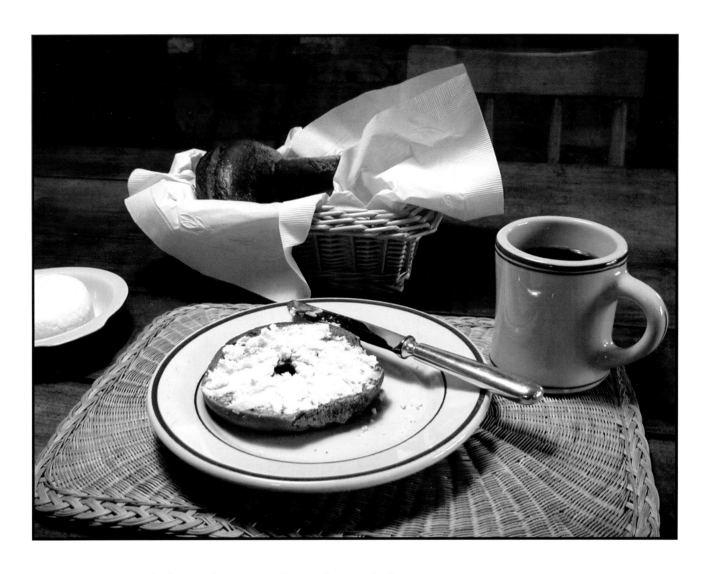

And for the perfect breakfast. Fresh goat cheese on a lightly toasted bagel with a cup of strong, freshly brewed coffee on the side, is a good way to start off your day. Once you have tried a really fresh goat cheese on your bagel, you will never go back to the ordinary cream cheese you used to put up with before you discovered goat cheese.